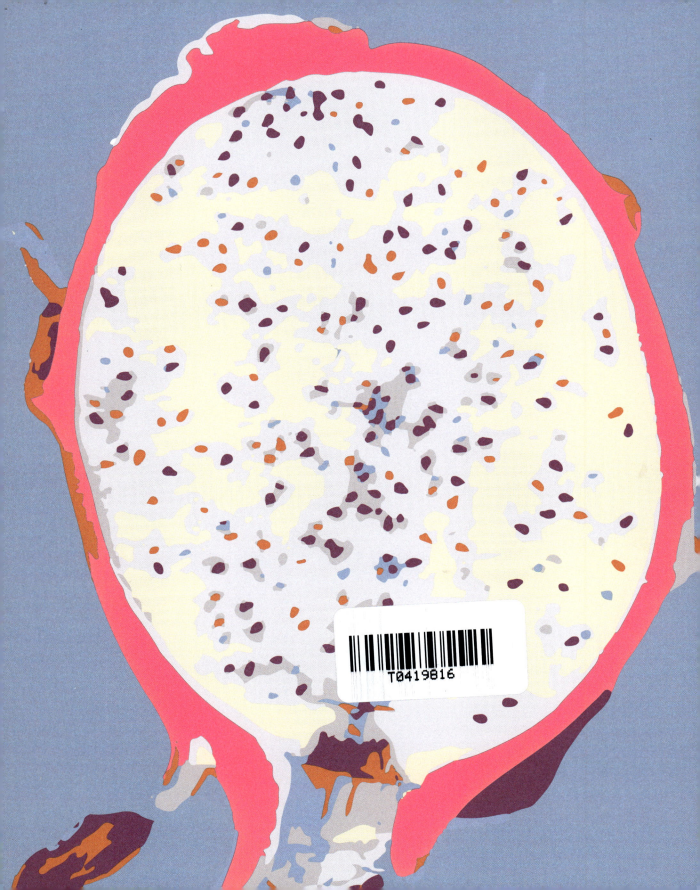

ANJA KLAFFENBACH

SUCCULENTS
SUKKULENTEN

teNeues

CONTENT
INHALT

FOREWORD	
VORWORT	10

BOTANY & HABITATS
BOTANIK & LEBENSRÄUME 16

What are succulents?	Was sind Sukkulenten?	18
Succulents around the world	Sukkulenten in aller Welt	20
Survival plants	Survival-Pflanzen	24
They store water, but how?	Wasser speichern – aber wie?	28
Succulents as climate regulators	30	
Sukkulenten als Klimapflanzen	31	
Cactuses in the snow?	Kakteen im Schnee?	34
Take a break	Mach mal Pause …	36
One thing at a time, please	38	
Sukkulenten als „Trennköstler"	39	

LEAF SUCCULENTS
BLATTSUKKULENTEN 40

Three dimensional plants	Pflanzen im 3D-Format	42
Magnificent desert-dweller	Prachtvolle Wüstenbewohnerin	44
Aizoaceae, or the fig-marigold family	46	
Mittagsblumengewächse	46	
Aloe species	*Aloe*-Arten	48

Crassulaceae & CAM	50
Crassula species \| *Crassula*-Arten	54
Echeveria: Natural masterpiece \| Kunstwerk der Natur	56
Kalanchoe blossfeldiana: Flaming Katy	58
Kalanchoe blossfeldiana: Flammendes Käthchen	58
Sansevieria trifasciata: Snake plant \| Bogenhanf	60
Sedum: Stonecrops & orpines \| Mauerpfeffer & Fetthenne	62
Sempervivum: Houseleek \| Hauswurz	66

STEM SUCCULENTS
STAMMSUKKULENTEN 68

The geometry of cactuses \| Die Geometrie der Kakteen	70
Euphorbiaceae: The spurge family \| Wolfsmilchgewächse	72
Milkweeds	74
Seidenpflanzengewächse	76
The amaranth family \| Fuchsschwanzgewächse	78
Beaucarnea recurvata: Elephant's foot \| Elefantenfuß	82
Brighamia insignis: Cabbage on a stick \| Hawaii-Palme	84

SUCCULENT ROOTS
WURZELSUKKULENTEN 88

Hidden cisterns \| Verborgene Speicher	90
Pelargoniums with water reservoirs	92
Pelargonien mit Wasserspeicher	92
Chlorophytum comosum: Common spider plant \| Grünlilie	94
Oxalis tuberosa: Uqa \| Knolliger Sauerklee	96

CONTENT | INHALT

GIVING SUCCULENTS AS GIFTS
SUKKULENTEN SCHENKEN 98

Hoya kerrii 100

Crassula ovata: For a positive outlook | Beste Aussichten 102

The language of succulents 104
Die Sprache der Sukkulenten 105

LIVING WITH SUCCULENTS
WOHNEN MIT SUKKULENTEN 108

Plants caught in the Zeitgeist 110
Pflanzen im Zeitgeist 110

Easy to live with | Unkomplizierte Mitbewohner 112

Succulents for better air quality 116
Sukkulenten als Luftverbesserer 117

Succulents as home accessories (1): Living in style 118
Sukkulenten als Wohnaccessoires (1): Ganz schön stylish 120

Succulents as home accessories (2): Greenery in small spaces 122
Sukkulenten als Wohnaccessoires (2): Grüne Minioasen 122

Creative planters | Kreative Pflanzgefäße 124

Plant poachers and *Dudleya farinosa* 128
Pflanzen-Wilderer und *Dudleya farinosa* 130

MEDICINE & COSMETICS
MEDIZIN & KOSMETIK 132

Aloe vera & Sempervivum: Healing with succulents? 134
Aloe vera & Sempervivum: Heilen mit Sukkulenten? 135

The real aloe | Die echte Aloe 138

Lophophora williamsii: Peyote, the psychedelic cactus	140
Lophophora williamsii: Psycho-Kaktus Peyote	141
The Hoodia diet \| Mit Hoodia auf Diät	142

CUISINE
KULINARIK 144

Weeds or nature's bounty?	146
Unkraut oder Geschenke der Natur?	147
Adansonia digitata: Baobab \| Affenbrotbaum	148
Opuntia: Prickly pear \| Kaktusfeige	152
Selenicereus undatus: Dragon fruit \| Drachenfrucht	154
Pickleweed and sea fennel	156
Queller, Meerfenchel & Co.	158

A BIZARRE VARIETY OF SHAPES
BIZARRE FORMENVIELFALT 160

Goethe and the amazing leaf \| Goethes Wunderblatt	162
Haworthia cooperi: Crystal clear \| Glasklares Pflanzenjuwel	166
Lithops: Living stones \| Lebende Steine	168
Cotyledon tomentosa: Bear's paw \| Bärentatze	170
Senecio rowleyanus: String-of-pearls \| Erbsenpflanze	172
Carnegiea gigantea: Saguaro	176
Cephalocereus senilis: Old man cactus \| Greisenhaupt	180
Selenicereus grandiflorus: Queen of the night	182
Selenicereus grandiflorus: Die Königin der Nacht	182

CONTENT | INHALT

FUN FACTS — 184

Schlumbergera species & *Hatiora gaertneri:* Christmas and Easter cactuses — 186
Schlumbergera-Arten & *Hatiora gaertneri:* Weihnachtskaktus, Osterkaktus & Co. — 187

Euphorbia leuconeura: Milk bush | Spuckpalme — 190

White stonecrop, the secret weapon of lazy gardeners — 192
Mauerpfeffer als Geheimwaffe für faule Gärtner — 194

Sempervivum tectorum: Protected by the common houseleek — 196
Sempervivum tectorum: Schutz fürs Dach — 196

Agave americana & *Agave tequilana:* Mescal & Tequila | Meskal & Tequila — 198

Agave lechuguilla: Ixtle — 202

Picture credits | Bildnachweis — 206
About the author | Die Autorin — 207

RIGHT PAGE | The fruit of the cactus *Selenicereus undatus* (see pp. 154–55), known as a pitahaya or dragon fruit, tastes as good as it looks.

RECHTE SEITE | Die als Pitahaya bekannten Früchte der Kakteenart *Selenicereus undatus* (siehe S. 154/155) sind so hübsch wie wohlschmeckend.

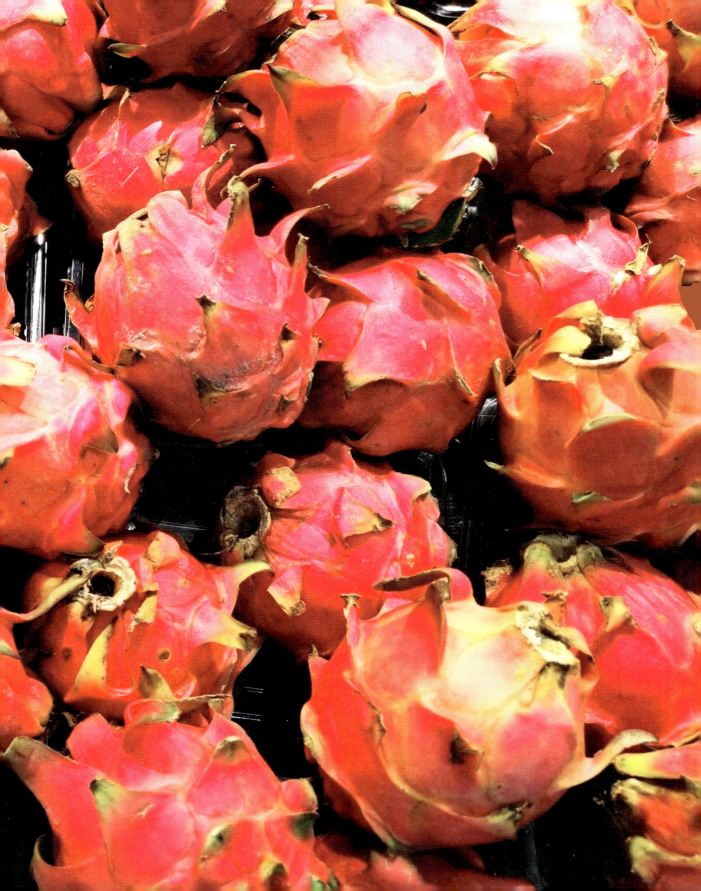

FOREWORD

EXPERIENCE THE FASCINATING WORLD OF SUCCULENTS

My enthusiasm for succulents began with a single *Echeveria* given to me as a gift when I moved into my first room at university, a space just big enough for a small plant. I could hardly believe it when my faithful *Echeveria* kept its fresh, delicate, blue-green shimmering appearance when no one watered it over break. My fascination with these resourceful survivors was born. And it continues to grow with each new addition to my collection, which I keep both inside and outdoors.

Nowadays, I am grateful to have a few sturdy green companions in my garden, especially during the increasingly hotter and drier summers. Houseleeks, stone orpine, sedum, and other varieties are ready for the challenges of climate change and are a delightful attraction for the eyes and for insects. Who knows? Perhaps this book will inspire you to take on a new succulent housemate or two.

Enjoy the journey as you discover and explore the captivating world of succulents.

Anja Klaffenbach

DIE FASZINIERENDE WELT DER SUKKULENTEN

Die Begeisterung für Sukkulenten begann mit einer einzelnen *Echeveria*, die ich für mein erstes Studentenzimmer geschenkt bekam: Für die kleine Sukkulente war dort gerade genug Platz – und ich konnte kaum glauben, dass meine treue *Echeveria* sogar nach den Semesterferien ohne Wasser frisch und zart in ihrer blaugrünen Eleganz schimmerte. So war meine Faszination für die Überlebenskünstler geweckt – und sie wächst noch immer mit jedem Neuzugang zum kleinen Sukkulenten-Sammelsurium drinnen und draußen.

Heute bin ich dankbar, in den immer heißeren, trockeneren Sommern mit Hauswurz, Tripmadam, Sedum & Co. ein paar robuste grüne Wegbegleiter in meinem Garten zu haben, die dem Unbill des Klimawandels trotzen und sowohl Insekten- wie auch Augenweide sind. Und wer weiß, vielleicht gibt es in diesem Buch die eine oder andere Inspiration für einen neuen sukkulenten Mitbewohner in Ihrem Zuhause?

Viel Vergnügen beim Entdecken und Erkunden der faszinierenden Welt der Sukkulenten!

Anja Klaffenbach

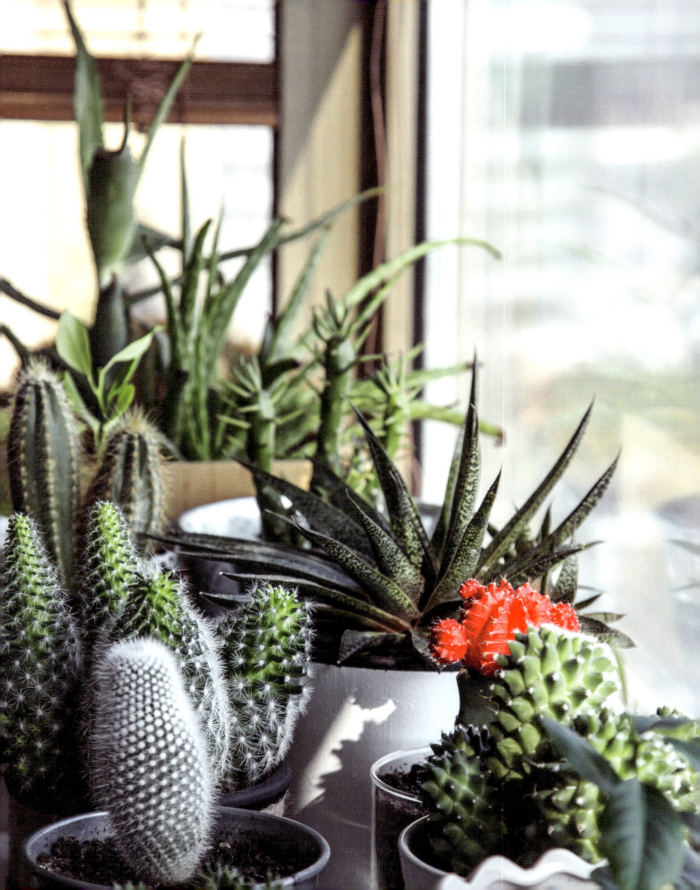

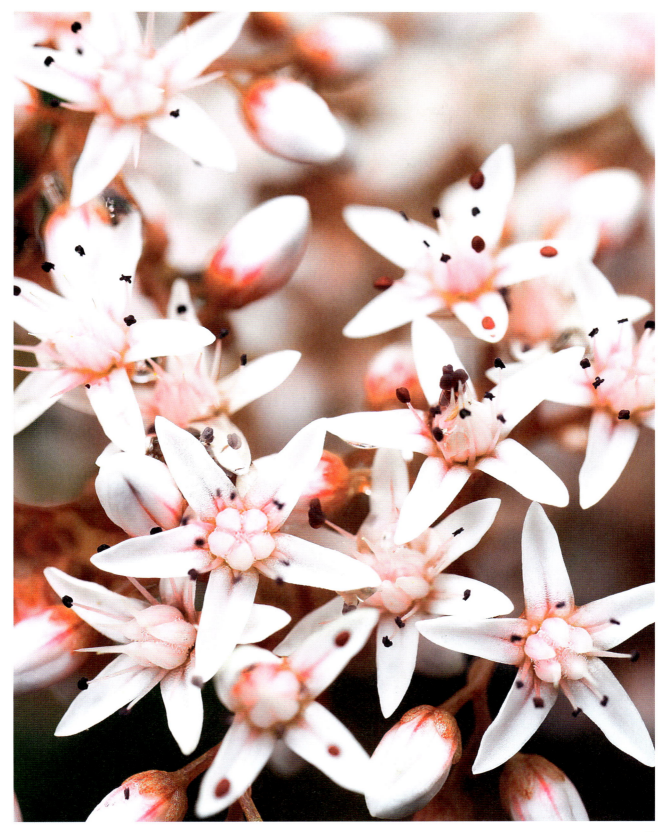

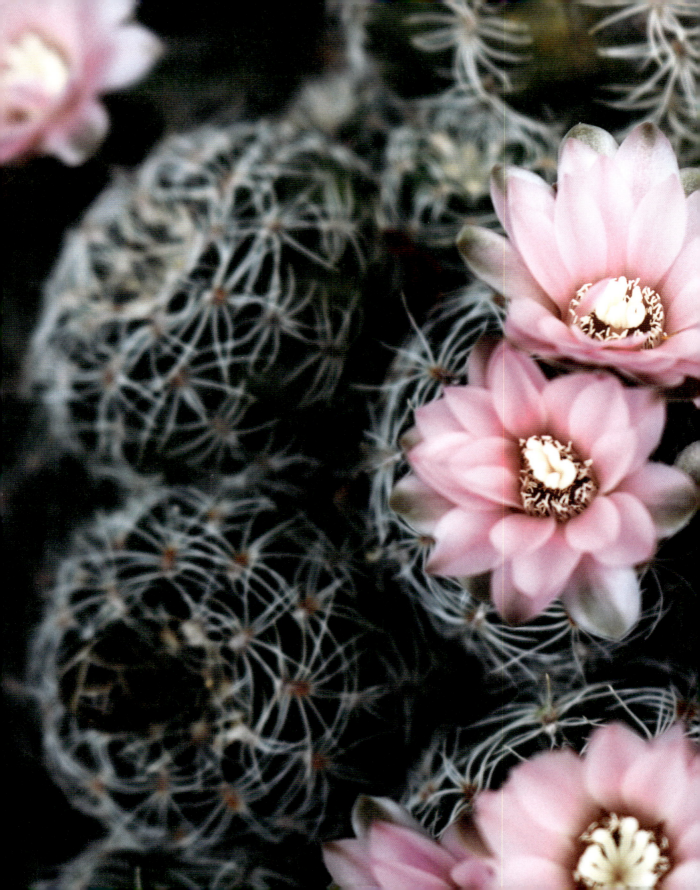

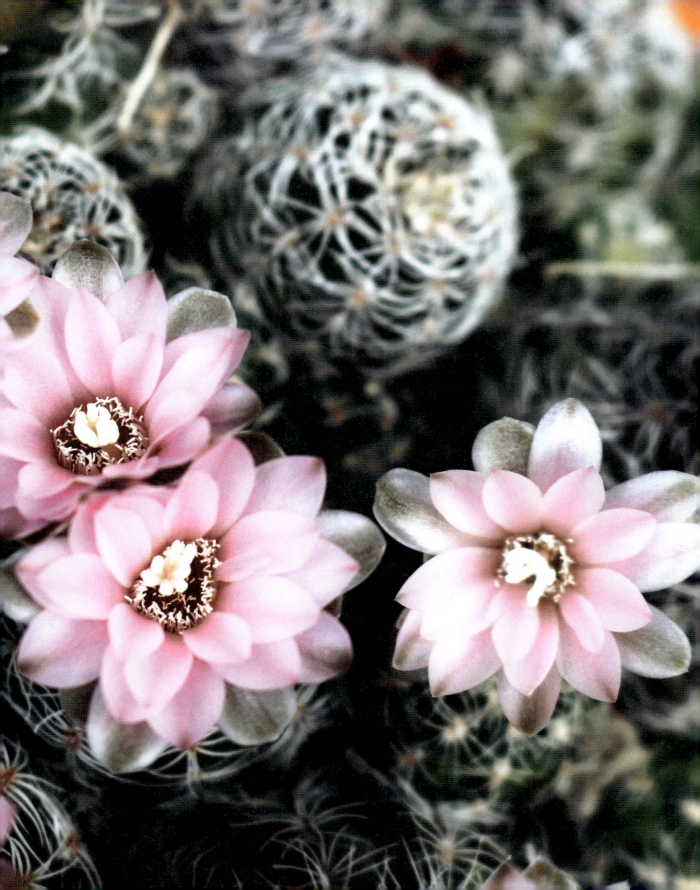

BOTANY & HABITATS

BOTANY & HABITATS

Succulent characteristics

WHAT ARE SUCCULENTS?

IT'S HARD TO GET A HANDLE ON THESE TALENTED PLANTS

Succulents are all the rage these days. But what exactly do people mean when they talk about succulents? Looking purely at botanical classifications—family, genus, species, *et cetera*—is small help when it comes to succulents. To cut a long story short, succulents are not a distinct taxonomic category. Instead, numerous genera contain plant species with succulent characteristics. The clue lies in the Latin term *suculentus* that gives them their name. It means "juicy" or "full of sap". What truly defines a succulent is its ability to store water.

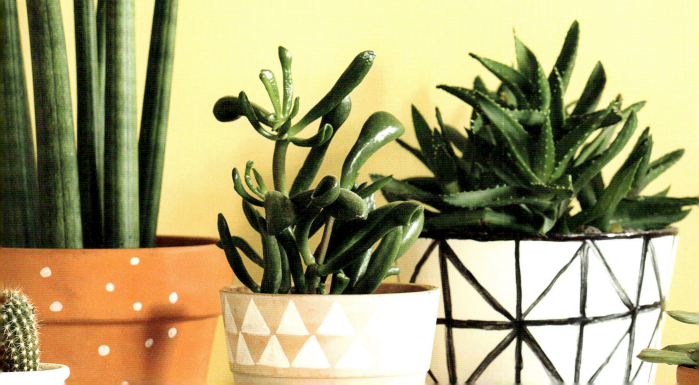

BOTANIK & LEBENSRÄUME

Sukkulenten & Co.

WAS SIND SUKKULENTEN?

TALENTIERTE PFLANZEN, DIE GAR NICHT SO EINFACH ZU FASSEN SIND

Sukkulenten sind Trend und in aller Munde – doch was genau versteht man eigentlich unter Sukkulenten? Rein über die botanische Taxonomie mit Pflanzenfamilie, Gattung, Art & Co. kommt man bei Sukkulenten nicht weiter. Um es kurz zu machen: Sukkulenten sind keine eigene Gattung, aber in vielen Gattungen gibt es Pflanzenarten mit sukkulenten Eigenschaften. Der namensgebende lateinische Begriff *suculentus* für „saftig" verrät es: Was eine Sukkulente ausmacht, ist ihre Fähigkeit, Wasser zu speichern.

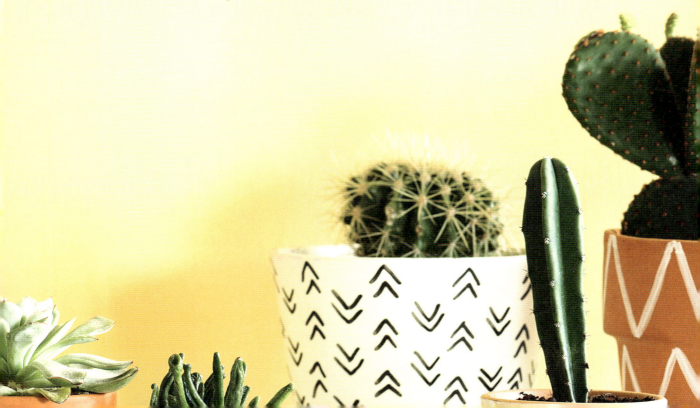

BOTANY & HABITATS

Succulents and their habitats (1)

SUCCULENTS AROUND THE WORLD

DESERT, RAINFOREST, OR ALPINE? EVERYWHERE, SUCCULENTS ARE MASTER ADAPTORS

Succulents are found on every continent except in polar regions and have adapted to the diverse living conditions of their respective habitats. However, cactuses, which also fall under the succulent umbrella, are exclusive to the Americas. While *Opuntia* and *Rhipsalis* are often cited as exceptions, these too are originally American and only spread to other continents through human intervention or by the activity of migratory birds. Africa's arid and semi-arid deserts are widely regarded as the home to the majority of stem and leaf succulents. A common feature among these plants is their adaptation to challenging conditions. In Africa, such conditions typically are prolonged dry spells and minimal rainfall.

 It's no paradox that plants that store water are found in tropical rainforests. Although it rains plenty in these regions, the moisture doesn't stick around in the treetops. There, the succulent traits of epiphytically growing orchids (for example) have become the key to their survival. Similarly, in Central Europe, primarily in alpine regions, succulents have carved out a niche, demonstrating resilience through extended cold snaps. The botanical name for *Sempervivum*, our hardy houseleek, the "ever-living plant", is therefore quite apt.

BOTANIK & LEBENSRÄUME

Lebensräume – Teil 1

SUKKULENTEN IN ALLER WELT

WÜSTE, REGENWALD ODER GEBIRGE? SUKKULENTEN SIND ÜBERALL WAHRE MEISTER DER ANPASSUNG

Auf allen Kontinenten, ausgenommen den polaren Regionen, kommen Sukkulenten vor. Kakteen, die ebenfalls zu den Sukkulenten zählen, sind jedoch nur auf dem amerikanischen Kontinent heimisch. Oft werden *Opuntia* und *Rhipsalis* hier als Ausnahme genannt, doch auch sie stammen ursprünglich aus Amerika und haben sich erst durch Menschen und Zugvögel auf anderen Kontinenten verbreitet. Die von Trockenheit geprägten Wüsten und Halbwüsten Afrikas gelten als Heimat der meisten Stammsukkulenten und Blattsukkulenten: Gemeinsam ist ihnen allen, dass sie sich an die herausfordernden Lebensbedingungen angepasst haben – in Afrika meist lange Trockenperioden und nur wenig Regen.

Dass es auch in den tropischen Regenwäldern Sukkulenten gibt, ist kein Widerspruch: Obwohl es dort nicht an Niederschlägen mangelt, hält sich die Feuchtigkeit hoch oben in den Baumkronen nicht lange – Sukkulenz wird so zum Beispiel bei epiphytisch wachsenden Orchideen zum Überlebensfaktor. Auch in Mitteleuropa, vornehmlich in den alpinen Regionen, haben Sukkulenten ihre Nische gefunden und trotzen sogar längeren Frostperioden. So kommt der botanische Name unserer robusten Hauswurz-Arten nicht von ungefähr: *Sempervivum* – die „immerlebende" Pflanze.

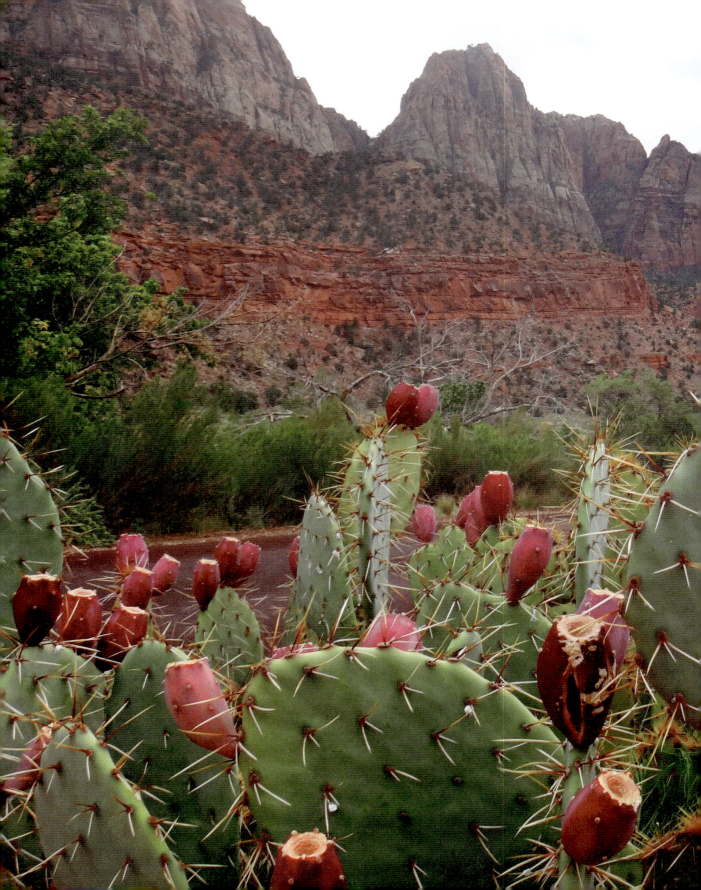

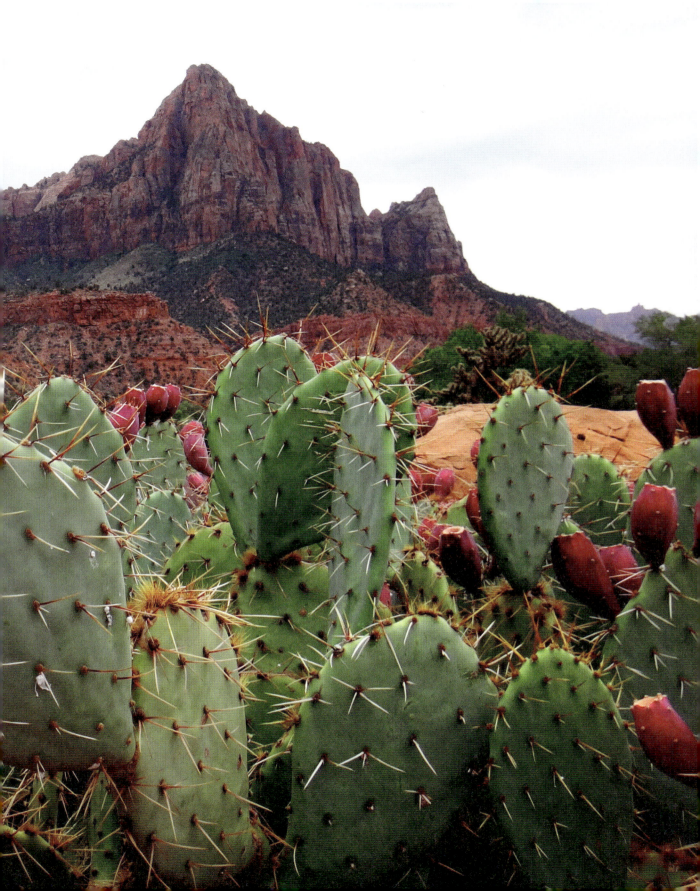

BOTANY & HABITATS

Succulents and their habitats (2)

SURVIVAL PLANTS

LOOK FOR WILD SUCCULENTS WHERE NOTHING ELSE WILL GROW

As water-storing plants, succulents are true survivalists. They've become established in challenging ecological niches like arid deserts and barren mountains where conditions are too harsh for other plants. As far as water is concerned, succulents go by the old maxim of "waste not, want not". Certain cactus species, among them the saguaro *Carnegiea gigantea*, can go for several years without rain thanks to their ability to store many hundreds of gallons of water.

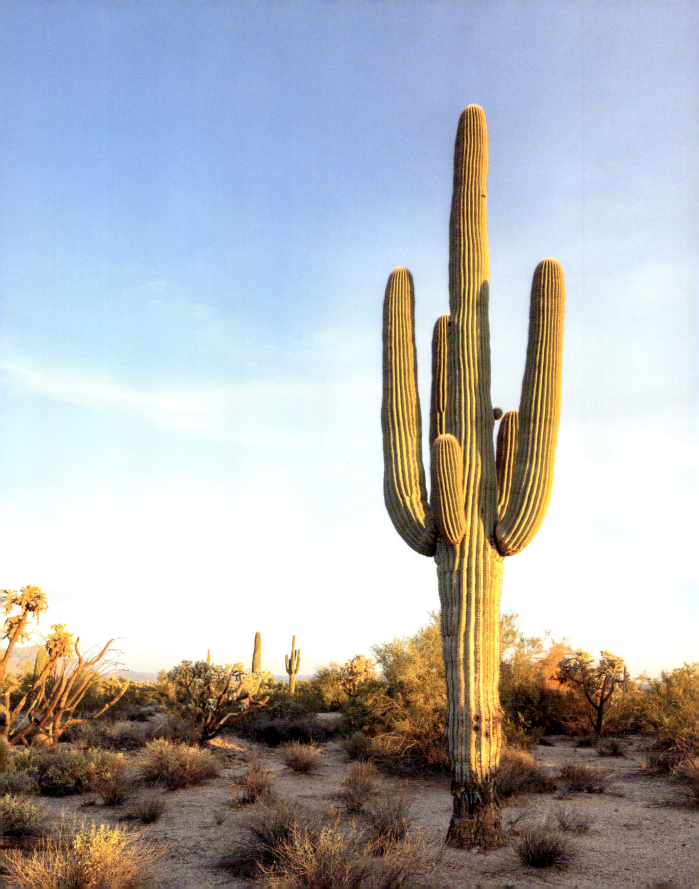

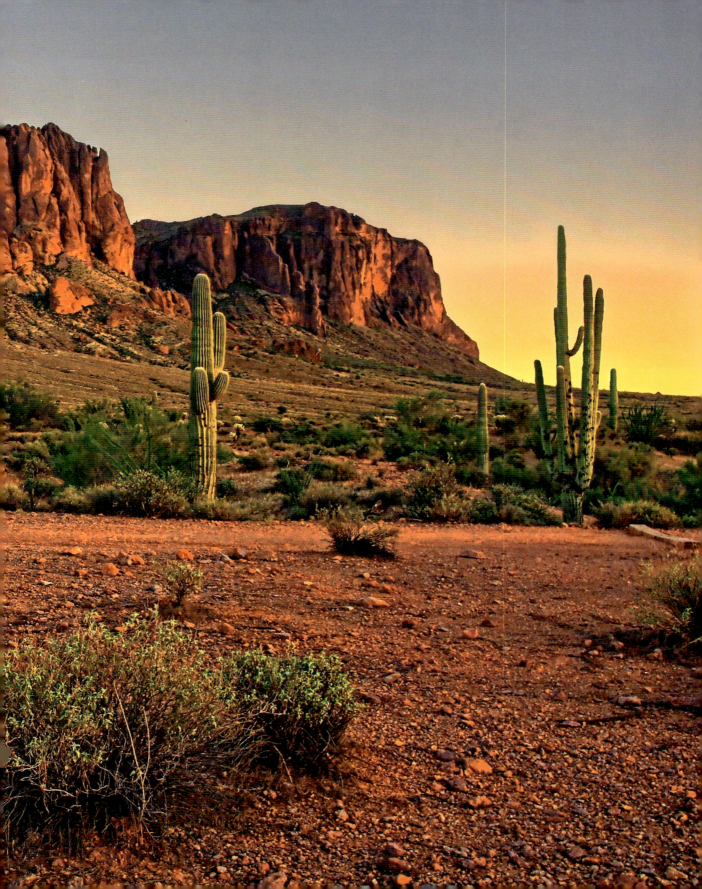

BOTANIK & LEBENSRÄUME

Lebensräume – Teil 2

SURVIVAL-PFLANZEN

WO FINDET MAN SUKKULENTEN IN DER NATUR? DORT, WO KAUM EINE ANDERE PFLANZE ZU FINDEN IST ...

Als Wasserspeicherpflanzen sind Sukkulenten wahre Überlebenskünstler. So haben sie sich Nischen wie trockene Wüstenregionen oder auch karge Gebirgsregionen erobert, in denen die Lebensbedingungen für andere Pflanzen zu schwierig sind. Was Wasser anbelangt, halten Sukkulenten es mit dem alten Sprichwort „Spare in der Zeit, dann hast du in der Not": Bestimmte Kakteenarten wie zum Beispiel *Carnegiea gigantea* überleben sogar etliche Jahre ohne Niederschläge, da sie Tausende Liter Wasser speichern können!

BOTANY & HABITATS

Succulence as a principle of survival

THEY STORE WATER, BUT HOW?

THICK GROWTH AND CISTERNS

Succulents pull off this impressive feat with special water-storing organelles called vacuoles tucked away in leaves, stems, roots, or sometimes a combination of these. Leaf succulents are perhaps the most notable succulents. Their typically thick, fleshy leaves are where these plants bunker water. They are flattered to be thick and fat.

Sukkulenz als Überlebensprinzip

WASSER SPEICHERN – ABER WIE?

FETTPFLANZEN MIT EINGEBAUTEN WASSERTANKS

Sukkulenten gelingt das mit einem speziellen Wasser speichernden Gewebe, den Vakuolen: Diese verbergen sich entweder in Blättern, Stämmen oder Wurzeln, manchmal auch in einer Kombination davon. Blattsukkulenten sind die vielleicht augenfälligsten Vertreter sukkulenter Pflanzen: In den für sie typischen dicken, fleischigen Blättern sind die „Wassertanks" der Pflanzen untergebracht, was ihnen auch die weniger schmeichelhaften Beinamen „Fettpflanzen" oder „Dickblattpflanzen" eingebracht hat.

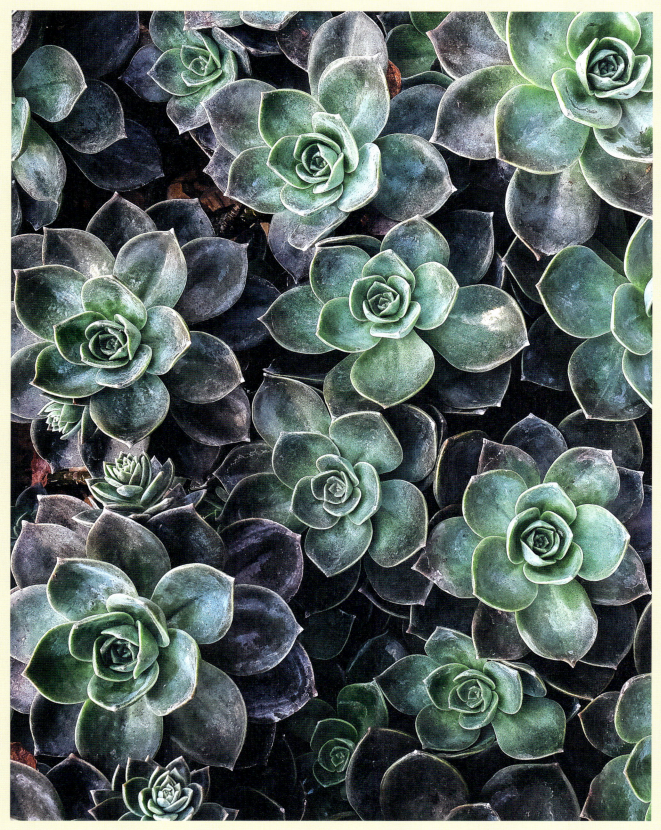

Sedum & Sempervivum

SUCCULENTS AS CLIMATE REGULATORS

SUCCULENTS ARE CONSUMMATE CLIMATE EXPERTS, PROVIDING URBAN AIR CONDITIONING THROUGH GREEN ROOFS

Heatwaves and deluges: Our urban areas, heavily paved, face massive challenges as the climate changes. Green spaces can aid in regulating the urban microclimate and enhance quality of life in the city. Widespread green roofs are a potential quick fix. This is where the colorful array of succulents native to the northern hemisphere come in: Plants like *Sedum* or *Sempervivum* resist hot and cold alike. Given that these low-maintenance succulents require only a small amount of substrate to be planted on, existing roof surfaces can be greened with relatively little effort.

Such a carpet of green on the roof brings many benefits. It insulates against extreme temperatures, whereas traditional flat roofs become like hotplates in the summer. A green oasis of *Sedum* or *Sempervivum*, or what have you, cools, produces oxygen, and can even absorb particulate matter and traffic noise. Furthermore, green roofs can act like a sponge during heavy rainfall, soaking up water and releasing the surplus gradually, which can help prevent sewers from backing up. And it's not just humans who benefit from succulents on the roof. Insects, too, find in green roofs an essential habitat in the otherwise barren urban jungle of concrete.

Sedum & Sempervivum

SUKKULENTEN ALS KLIMAPFLANZEN

SUKKULENTEN SIND ECHTE KLIMAKÜNSTLER – UND KÖNNEN ALS DACHBEGRÜNUNG ZU URBANEN „KLIMAANLAGEN" WERDEN!

Hitzewellen oder Überflutungen durch Starkregen – der Klimawandel stellt unsere Städte mit ihren stark versiegelten Flächen vor große Herausforderungen. Mehr Grünflächen können helfen, das urbane Mikroklima zu regulieren und die Lebensqualität zu verbessern. Die schnelle Lösung: extensive Dachbegrünung! Hier kommt die bunte Vielfalt an Sukkulenten der nördlichen Hemisphäre ins Spiel: *Sedum*, *Sempervivum* & Co. sind hart im Nehmen – sowohl was Hitze als auch Kälte anbelangt. Da die anspruchslosen Sukkulenten mit nur wenig Pflanzsubstrat auskommen, können auch bestehende Dachflächen ohne großen Aufwand begrünt werden. „Grüne Teppiche" auf dem Dach bringen viele Vorteile: Sie wirken isolierend und fangen so Temperaturspitzen auf. Während konventionelle Flachdächer im Sommer zum „heißen Stein" werden, wirkt eine grüne Oase mit Mauerpfeffer, Dachwurz und anderen Sukkulenten kühlend, produziert Sauerstoff und absorbiert sogar Feinstaub und Verkehrslärm. Zudem wirken Gründächer bei Starkregen wie ein Schwamm: Sie saugen Wasser auf und geben Überschüsse mit dosierter Verzögerung ab, sodass das Abwassersystem nicht überlastet wird. Und nicht nur wir Menschen profitieren von Sukkulenten auf Dächern – auch Insekten finden hier einen wichtigen Lebensraum im sonst so kargen urbanen Betondschungel.

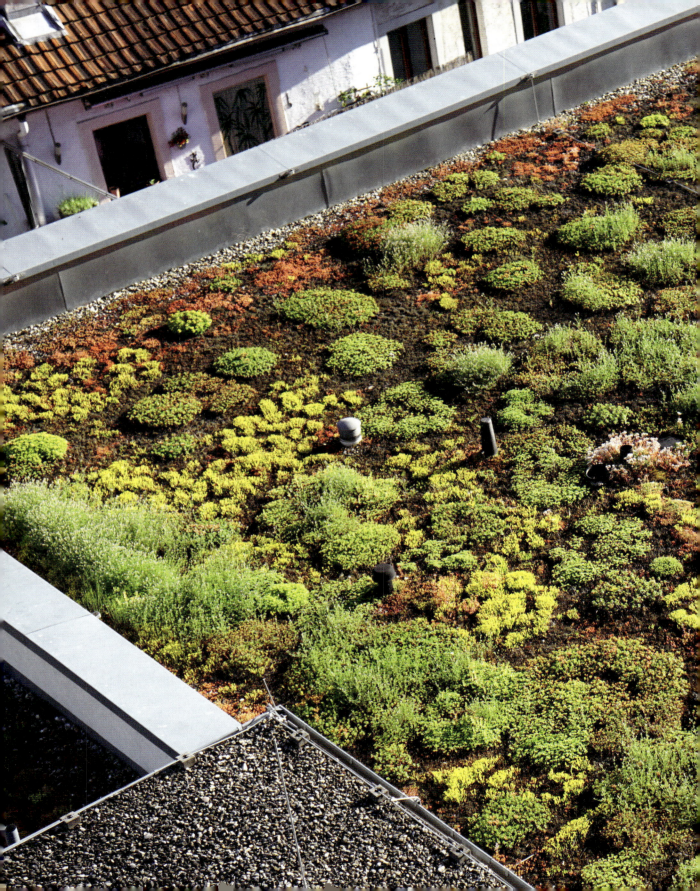

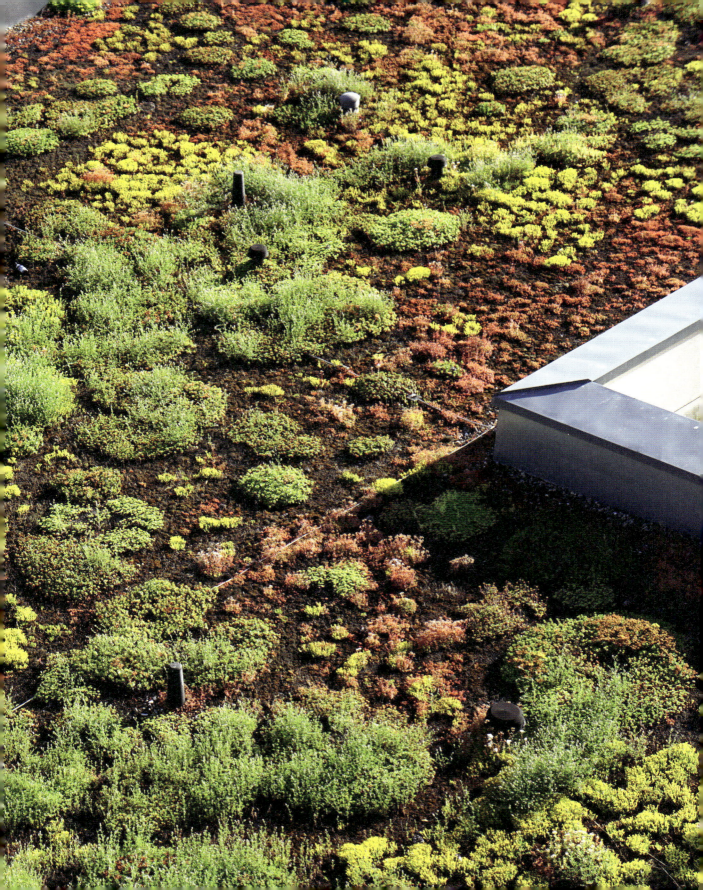

BOTANY & HABITATS

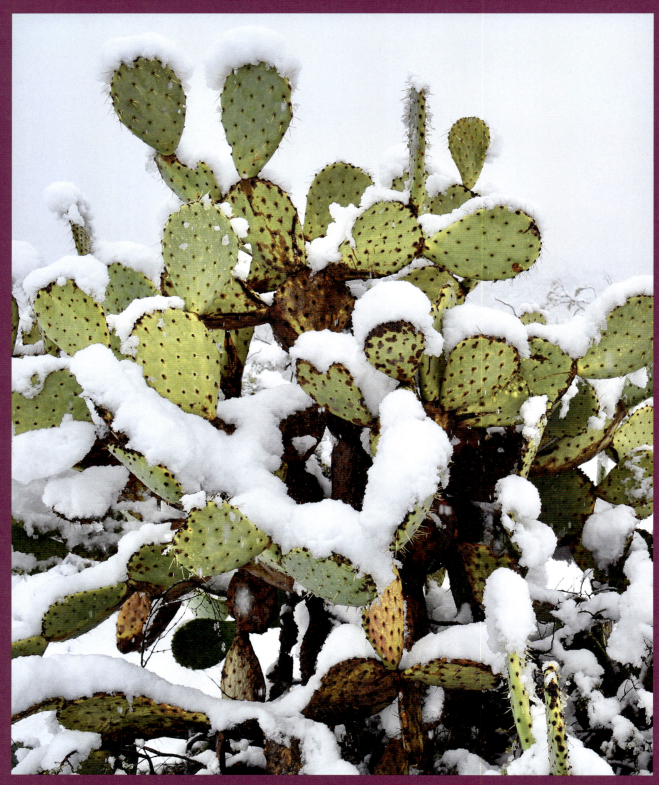

BOTANIK & LEBENSRÄUME

Opuntia

CACTUSES IN THE SNOW?

CACTUSES HAVE ANOTHER RABBIT UP THEIR SLEEVE FOR FROST

Cactuses certainly like it hot, but can they take a chill? Below-freezing temperatures are common in deserts, and the survival strategy of cactuses is to shrivel. By dehydrating their water-storing vacuoles ahead of a cold snap, cactuses can prevent them bursting due to frost. Some species of *Opuntia* can withstand zero-degree temperatures (and that's Fahrenheit!). But it's only the case if the plant manages to drain its reservoirs in time.

KAKTEEN IM SCHNEE?

AUCH BEIM FROSTSCHUTZ HABEN KAKTEEN EINEN TRICK AUF LAGER

Kakteen lieben Wärme – aber können sie es auch mit kalten Temperaturen aufnehmen? In Wüstenregionen sind Minusgrade keine Seltenheit. Die Überlebenstaktik der Kakteen: Verschrumpeln! Wenn Kakteen rechtzeitig vor Kälteperioden ihre wasserspeichernden Vakuolen dehydrieren, verhindern sie deren Aufplatzen durch Frost. Einige *Opuntia*-Arten können auf diese Art sogar Minusgrade weit im zweistelligen Bereich ertragen. Generell gilt aber: Nur wenn das „Trockenlegen" gelingt, kann der Kaktus überleben.

BOTANY & HABITATS

Metabolism throughout the year

TAKE A BREAK

LIFE'S UPS AND DOWNS: ONLY DORMANT PERIODS ALLOW SUCCULENTS TO BLOSSOM

Take frequent breaks, recharge, then bloom anew? It's a lesson we humans could perhaps learn from the plants. Succulents require extensive rest, which they typically find in the winter months, when temperatures drop, and these plants stop growing and begin to downregulate their metabolisms. As soon as warmth, light, and nutrients become readily available again, new roots form rapidly to replenish the plant's energy stores. Now aloe, agave, stonecrop, *et cetera* are rested and ready for a lush flowering season.

Stoffwechsel im Jahreslauf

MACH MAL PAUSE …

DAS AUF UND AB DES LEBENS: ERST RUHEZEITEN LASSEN SUKKULENTEN AUFBLÜHEN

Öfter mal eine Pause machen, damit man wieder aufblühen kann? Vielleicht eine Lektion, die wir Menschen von Pflanzen lernen können … Sukkulenten brauchen eine ausgiebige Ruhephase, meist in den Wintermonaten: Ein Kälteimpuls veranlasst die Pflanzen, den Stoffwechsel herunterzufahren, das Wachstum stagniert. Sobald wieder mehr Wärme, Licht und Nährstoffe im Angebot sind, werden flugs neue Wurzeln ausgebildet, um frische Energie zu tanken – und Aloe, Agave, Fetthenne & Co. sind bereit für eine üppige Blütezeit!

BOTANIK & LEBENSRÄUME

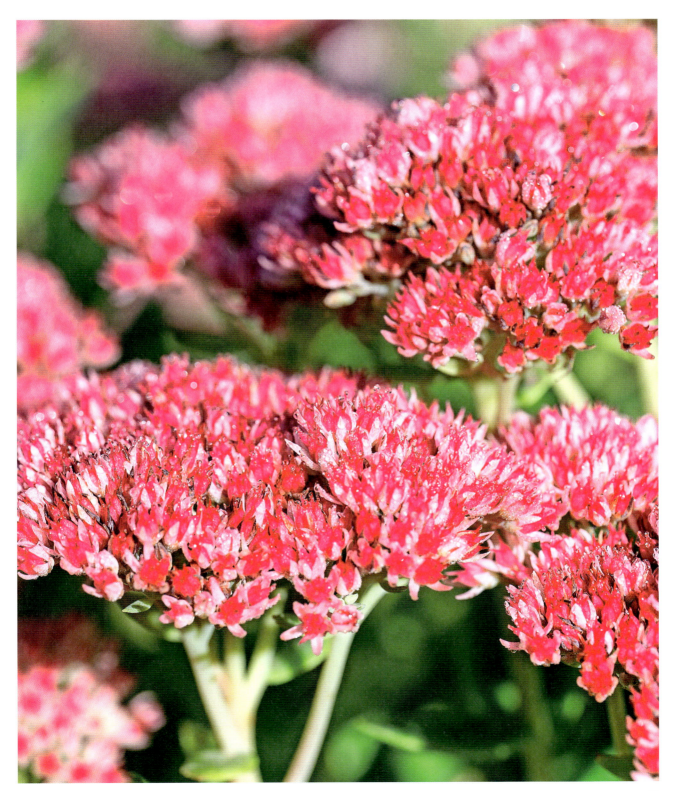

BOTANY & HABITATS

CAM photosynthesis

ONE THING AT A TIME, PLEASE

PHOTOSYNTHESIS REQUIRES LIGHT AND CO_2. SUCCULENTS HAVE GOOD REASONS FOR TAKING THEM SEPARATELY

Like any plant, succulent metabolisms rely on light and carbon dioxide. But if a succulent were to open its stomata during the day to absorb CO_2, it would lose valuable water to evaporation through those very same openings. Ingeniously, then, they only open their stomata in the cool of night. Their metabolism is divided into two phases and aided by CAM photosynthesis. CAM stands for "Crassulacean acid metabolism". Obviously, the sun doesn't shine at night. For this reason, succulents store CO_2 in their cells in the form of malic acid. During the day, the stomata remain closed, and stored CO_2 is released. This is when photosynthesis proper can begin.

BOTANIK & LEBENSRÄUME

CAM-Photosynthese

SUKKULENTEN ALS „TRENNKÖSTLER"

ZUR PHOTOSYNTHESE SIND LICHT UND CO_2 NÖTIG –
VIELE SUKKULENTEN NEHMEN AUS GUTEN GRÜNDEN
ABER EINS NACH DEM ANDEREN AUF ...

Auch der Stoffwechsel von Sukkulenten verlangt nach Licht und CO_2 – doch würden sie zur CO_2-Aufnahme ihre Spaltöffnungen, Stomata genannt, tagsüber aufmachen, würde auch das wertvolle gespeicherte Wasser verdunsten. Ganz schön clever: Sie öffnen ihre Stomata nur in der Nachtkühle und spalten den Stoffwechsel in zwei Phasen auf – die CAM-Photosynthese (CAM = *Crassulacean Acid Metabolism*) hilft ihnen dabei. Weil nachts das Sonnenlicht fehlt, speichern Sukkulenten das CO_2 in Form von Äpfelsäure in ihren Zellen. Tagsüber werden die Stomata dann geschlossen und das gespeicherte CO_2 wird freigegeben – die Photosynthese kann beginnen.

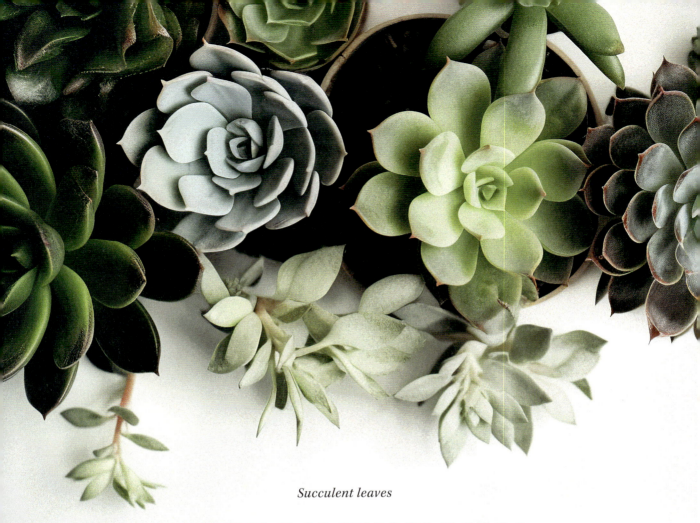

Succulent leaves

THREE DIMENSIONAL PLANTS

EXPANSION, CONTRACTION, AND THE AVAILABILITY OF WATER

Succulents are survival artists that have perfected the art of maximizing water storage while minimizing surface area, their formula for reducing evaporation. Thick, three-dimensional leaf shapes are the succulents' hallmark. These leaves house storage tissue that expands like an accordion, enabling them to fill up on water. If the plant needs to tap into its reserves during a dry spell, the tissue contracts, resulting in a decrease in the plant's volume and storage capacity but no permanent harm to the plant itself.

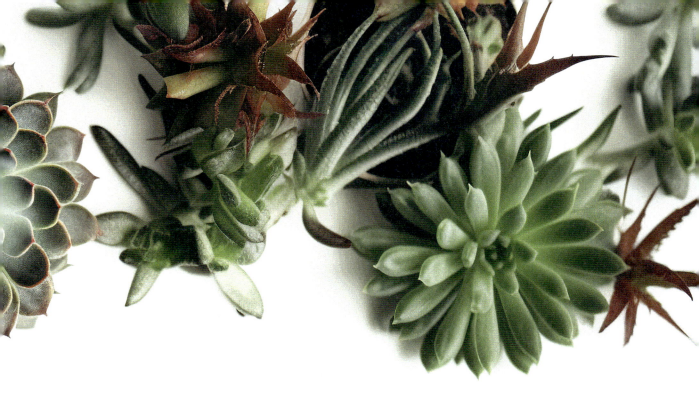

Blattsukkulenz

PFLANZEN IM 3D-FORMAT

DICKE BLÄTTER UND DER ZIEHHARMONIKAEFFEKT

Maximales Wasserspeichervolumen bei minimaler Oberfläche: Mit dieser Formel minimieren sukkulente Überlebenskünstler die Verdunstung. Meist zeichnen sich Sukkulenten daher durch dicke, dreidimensionale Blattformen aus: Im Inneren kann sich das Speichergewebe wie eine Ziehharmonika ausdehnen, um mehr Wasser zu „tanken". Muss die Pflanze zu Trockenzeiten von ihrem Vorrat zehren, schrumpft das Gewebe und somit auch das Volumen der Pflanze, ohne jedoch dauerhaften Schaden zu nehmen.

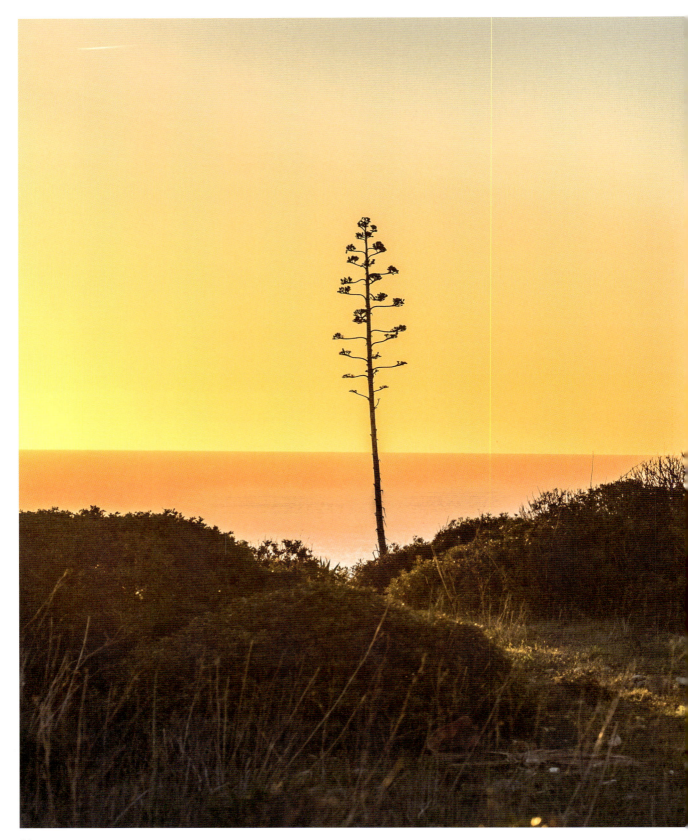

BLATTSUKKULENTEN

Agave americana

MAGNIFICENT DESERT-DWELLER

THE "CENTURY PLANT" TAKES ITS TIME

The striking rosettes of the agave betray the origins of its name, derived from the Greek αγαυός, which amounts to "magnificent". *Agave americana*, also known as the "century plant", lives up to the name, a resilient desert-dweller that often vegetates for decades before reaching its flowering stage. Technically speaking, however, most agaves are not perennials. Their flower stalks may grow to be well over twenty feet tall, but after blooming, the entire plant withers.

PRACHTVOLLE WÜSTENBEWOHNERIN

SIE LÄSST SICH OFT VIEL ZEIT

Die eindrucksvollen Agaven-Rosetten lassen erkennen, wie sich die in Amerika heimische Blattsukkulente ihren Namen verdient hat: Das griechische αγαυός bedeutet so viel wie „prachtvoll". Die *Agave americana* gilt auch als „Jahrhundertpflanze", vergehen doch oft mehrere Jahrzehnte, bis die genügsame Wüstenbewohnerin zum Blühen kommt. Mehrjährig sind die meisten Agaven deswegen trotzdem streng genommen nicht: Nachdem sie einmalig an ihrem oft meterhohen Stiel erblüht ist, stirbt die ganze Pflanze ab.

LEAF SUCCULENTS

Aizoaceae

AIZOACEAE, OR THE FIG-MARIGOLD FAMILY

ICE CRYSTALS AND SUN-BATHERS

Aizoaceae, a family of perennials, combines hot and cold. On one hand, they blossom extravagantly in the midday heat (in German they're called *Mittagsblumen*, "noontime flowers"). The reason for the English name "ice plant", on the other hand, is their leaves. They sport fine, frost-like hairs like tiny ice crystals. These unusual external water reservoirs help regulate the plant's salt content, especially given these succulents' coastal habitats. Certain of them, including *Mesembryanthemum crystallinum*, are edible.

MITTAGSBLUMEN-GEWÄCHSE

EISKRISTALLE UND SONNENANBETER

Die ausdauernden *Aizoaceae* verbinden heiß und kalt: In der Mittagshitze blühen sie am üppigsten auf und machen ihrem deutschen Namen Mittagsblumen so alle Ehre. Manche Arten wie *Mesembryanthemum crystallinum* sind sogar essbar, und ein Blick auf deren Blätter erklärt den englischen Popularnamen *Ice Plant*: Feine, raureifartige Härchen wirken wie winzige Eiskristalle und sind ungewöhnliche außen liegende Wasserspeicher, die den Salzhaushalt der in Küstennähe wachsenden Sukkulente regulieren.

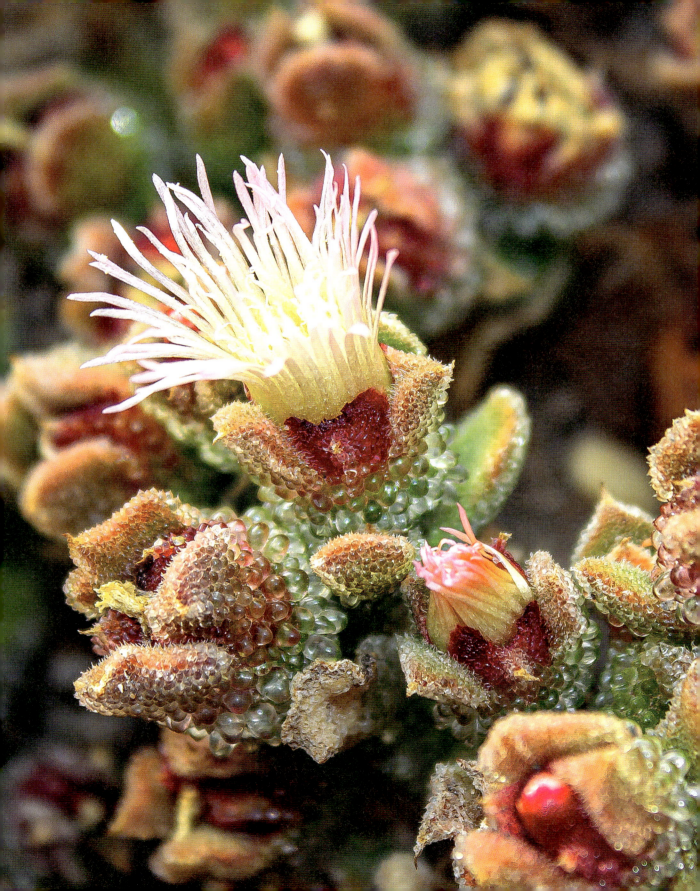

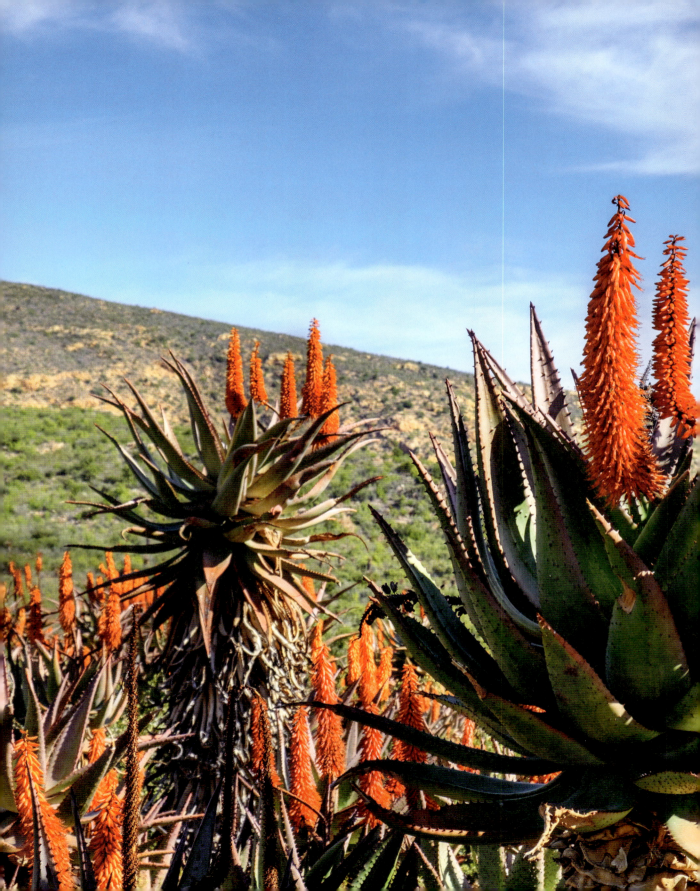

Aloe species

CUTTING-EDGE

THESE LEAF SUCCULENTS GROW IN A SPLENDID ROSETTE PATTERN

Aloes have impressive, serrated ridges on the edge of their pointy leaves. *Aloe dichotoma*, native to South Africa and Namibia, stands out among about 500 other species of aloe. Its stem can grow to be a staggering thirty feet high. Equally remarkable to look at is the spiral aloe, *Aloe polyphylla*. Its leaves, often tinged with purple at the tips, coil around one another in five symmetrical rows, creating a mesmerizing natural mandala.

Aloe-Arten

GANZ SCHÖN AUF ZACK

DIESE BLATTSUKKULENTEN WACHSEN IN PRÄCHTIGEN ROSETTEN

Aloe beeindrucken mit sägeblattscharfen Zacken an spitzen Blättern. Herausragend unter den rund 500 Aloe-Arten ist die in Südafrika und Namibia heimische *Aloe dichotoma*: Der Stamm der auch Köcherbaum genannten Sukkulente wird bis zu neun Meter hoch! Optisch sticht auch *Aloe polyphylla*, die Spiralaloe, hervor: Ihre Blätter mit oft lilafarbenen Spitzen winden sich in fünf gleichmäßigen Reihen spiralförmig umeinander – ein faszinierendes Sukkulenten-Mandala der Natur.

LEAF SUCCULENTS

Crassulaceae & CAM

THE CLEVER ORPINE FAMILY

THE BIG LEAGUE OF WATER STORAGE AND METABOLIC INNOVATION

The *Crassulaceae* family, comprising approximately 35 genera and more than 1,400 distinct species, is global and diverse. In all their diversity of appearance, *Crassulaceae*—the name comes from the Latin *crassus*, for "thick"—are noteworthy for their fleshy leaves, which store the water crucial to these succulents' survival in varied conditions. This plant family lends its name to a unique type of photosynthesis known as CAM, which is typical of succulents in general. And given current concerns about climate change and rising temperatures, CAM photosynthesis has become a compelling research topic. How can we optimize crop metabolisms to ensure harvests even in drought conditions? Way back in 1813, botanist Benjamin Heyne discovered the role of malic acid in what came to be called Crassulacean acid metabolism (CAM). He made his discovery experimenting unwittingly on himself. He bit into leaves of the medicinal *Bryophyllum calycinum* (yes, the one that so intrigued Goethe) at various times of the day and found them to be extremely sour in the early morning yet virtually tasteless come afternoon.

RIGHT PAGE | The blueish-green leaves of *Bryophyllum fedtschenkoi* turn reddish if the plant is exposed to very hot or dry conditions.

NEXT PAGE | From abscesses to toothaches, *Bryophyllum calycinum* is used to treat so many different ailments that it has been called a miracle plant.

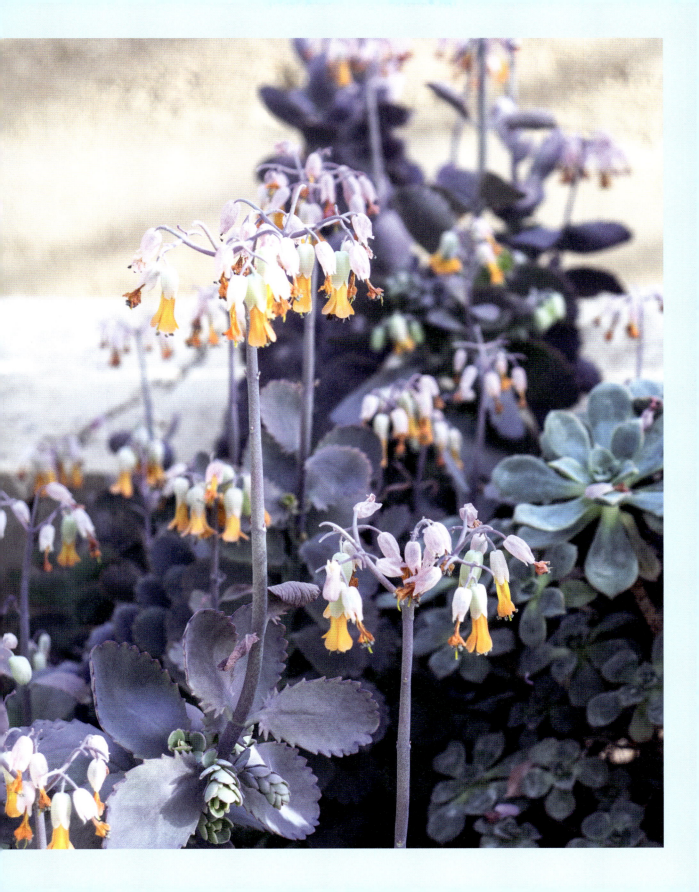

BLATTSUKKULENTEN

Crassulaceae & CAM

CLEVERE GEWÄCHSE

WASSERSPEICHERPROFIS UND WEGWEISENDE STOFFWECHSELKÜNSTLER

Die Familie der *Crassulaceae* ist vielfältig und rund um die Erde verbreitet, mit rund 35 Gattungen und mehr als 1400 verschiedenen Arten. *Crassulaceae* – das namensgebende lateinische *crassus* bedeutet „dick" – zeichnen sich in ihrer Formenvielfalt immer durch die charakteristischen fleischigen Blätter aus, die den Sukkulenten als überlebenssichernde Wasserspeicher dienen. Die Pflanzenfamilie ist namensgebend für die spezielle sukkulententypische Art der CAM-Photosynthese und, Klimawandel und Hitzerekorden geschuldet, ein spannendes Forschungsfeld: Wie kann es gelingen, bei Nutzpflanzen den Stoffwechsel zu optimieren und so auch bei Trockenheit Ernteausfälle zu verhindern? Dass beim *Crassulacean Acid Metabolism* (CAM) Äpfelsäure eine Rolle im Stoffwechsel spielt, entdeckte der Botaniker Benjamin Heyne bereits 1813 im zufälligen Selbstversuch: Er biss zu unterschiedlichen Tageszeiten in Blätter der auch als Heilpflanze verwendeten *Bryophyllum calycinum* – genau, die Pflanze, von der auch Goethe so fasziniert war – und bemerkte, dass diese frühmorgens extrem sauer schmeckten, nachmittags aber nahezu geschmacksneutral waren.

VORIGE SEITE | Das Blaugrün der Blätter von *Bryophyllum fedtschenkoi* kann sich bei starker Hitze oder Trockenheit rötlich färben.

LINKE SEITE | Von Abszess bis Zahnschmerz: Mit dem vielfältigen Einsatz bei Gesundheitsbeschwerden hat sich *Bryophyllum calycinum* den Beinamen „Wunderpflanze" erworben.

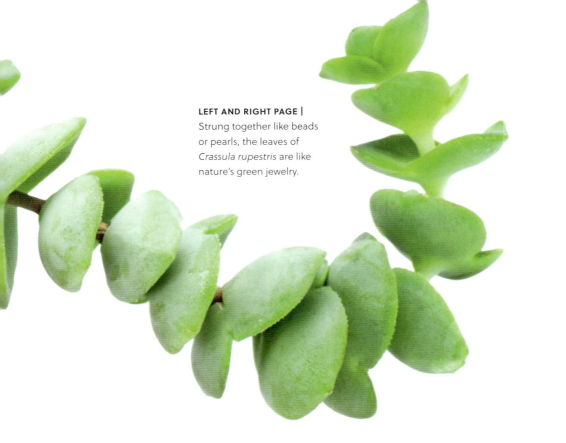

LEFT AND RIGHT PAGE | Strung together like beads or pearls, the leaves of *Crassula rupestris* are like nature's green jewelry.

Crassula species

OF RATS AND NECKLACES

RATTAIL. WATCH CHAIN. SOME *CRASSULA* SPECIES HAVE ODD NAMES

Much has changed since Carl von Linné first characterized ten species in the genus *Crassula* in 1753. Today, we recognize over 200 species that exhibit a vibrant array of forms. The elongated shoots of *Crassula muscosa* have earned it the playful moniker "rattail", though some have thought "watch chain" or "zipper plant" more fitting. Has *Crassula ovata* round leaves that look like coins? Let's call it the "money tree". *Crassula rupestris*, known as "buttons on a string", has also courted a plethora of imaginative associations with other names, like the "kebab plant" or "baby necklace". The associations, it seems, are endless.

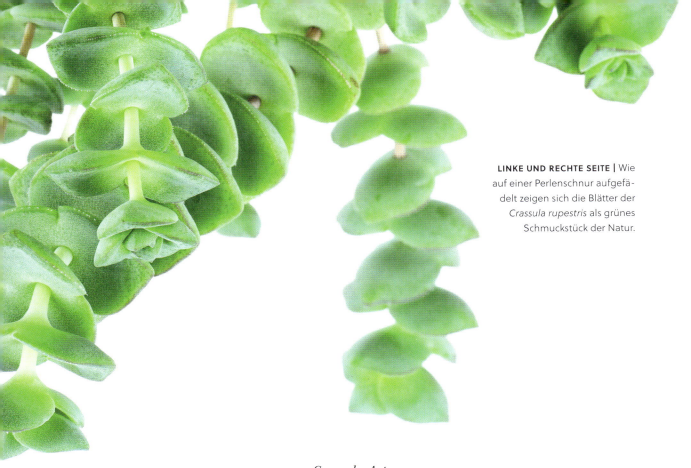

LINKE UND RECHTE SEITE | Wie auf einer Perlenschnur aufgefädelt zeigen sich die Blätter der *Crassula rupestris* als grünes Schmuckstück der Natur.

Crassula-Arten

VON MÄUSEN UND HALSKETTEN

DICKBLATTARTEN HABEN BISWEILEN SKURRILE NAMEN

Seit Carl von Linné 1753 die Gattung *Crassula* mit zehn Arten beschrieb, hat sich einiges getan: Heute kennen wir über 200 mit bunter Formenvielfalt. Ihre langen Triebe haben *Crassula muscosa* den Namen Mäuseschwanz-Pflanze eingebracht, im Englischen fühlte man sich mit *Watch Chain* und *Zipper Plant* wohl eher an Uhrenkette und Reißverschluss erinnert. Runde Blätter, die wie Münzen aussehen? Schon hat *Crassula ovata* den Namen Geldbaum verdient. Und bei *Crassula rupestris* blüht die Fantasie wild auf: Kebap-Pflanze, Baby-Halskette oder Knöpfe auf einer Schnur – die Assoziationen sind vielfältig.

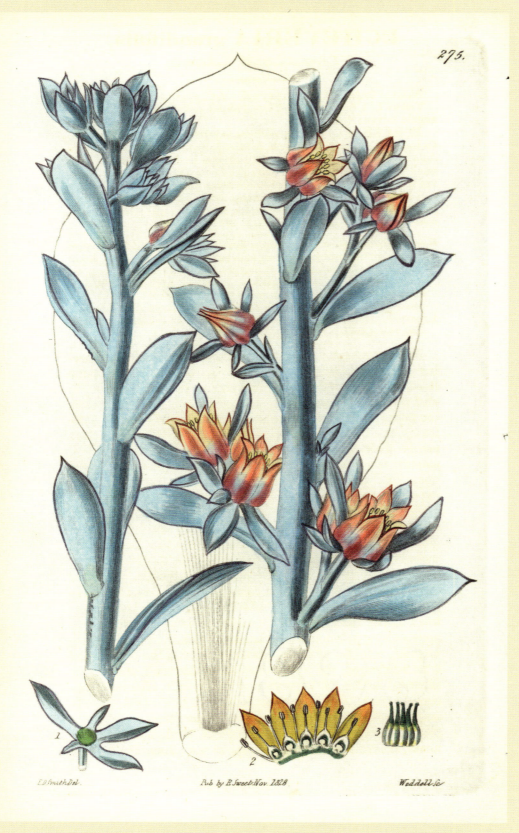

An 1828 engraving by Weddell, based on a watercolor by botanical illustrator Edwin Dalton Smith, records the delicate beauty of *Echeveria grandifolia*.

Auch Weddells Kupferstich von 1828, nach einem Aquarell des botanischen Illustrators Edwin Dalton Smith, fängt die zarte Schönheit der *Echeveria grandifolia* ein.

Echeveria

NATURAL MASTERPIECE

NAMED FOR AN ARTIST WHOSE TALENT WAS ONLY RECOGNIZED POSTHUMOUSLY

Echeveria was christened in 1828 in honor of the young botanical artist Atanasio Echeverría y Godoy. He had encountered these spectacular succulents four decades earlier on an expedition to the Mexican desert and immortalized their beauty in watercolor paintings. The pastel, green-to-lilac rosettes formed by *Echeveria* leaves are indeed natural masterpieces. Their delicate coloration stems from a thin layer of wax that envelopes their succulent leaves. However, a word of caution: even the slightest touch can mar this powdery farina.

KUNSTWERK DER NATUR

NAMENSPATE IST EIN KÜNSTLERISCHES TALENT, DAS ERST POSTHUM WÜRDIGUNG FAND

1828 wurde die *Echeveria* nach dem jungen botanischen Zeichner Atanasio Echeverría y Godoy benannt, der die prachtvollen Sukkulenten rund 40 Jahre zuvor bei einer Expedition in der mexikanischen Wüste entdeckt und in Aquarellen festgehalten hatte. Die pastellgrünen bis fliederfarbenen Blattrosetten der *Echeveria* sind wahre Kunstwerke der Natur. Ihre zarte Färbung kommt von einer feinen Wachsschicht um die fleischigen Blätter. Doch Vorsicht: Schon eine leichte Berührung kann diese pudrige Farina zerstören.

LEAF SUCCULENTS

Kalanchoe blossfeldiana

FLAMING KATY

FIERY FLOWERS AND CLEVER REPRODUCTION

In China, these plants are referred to as *kalan chau*. Those familiar with the translation, "that which falls and grows", can see the relationship to *Kalanchoe*'s efficient propagation through shoots that drop off the mother plant. Of the roughly 125 species, the most renowned is the *Kalanchoe blossfeldiana*, originating from Madagascar. Adorned with flowers in vibrant fiery tones, this "flaming Katy" lives up to its name. *Kalanchoe* generally consists of short-day plants, but gardeners can coax them into blooming when days are long by putting them to bed early—in a dark box.

FLAMMENDES KÄTHCHEN

FEURIGE BLÜTEN UND CLEVERE FORTPFLANZUNG

In China nennt man sie *Kalan Chau*. Wer die Übersetzung mit „was fällt und wächst" kennt, ahnt, dass sich *Kalanchoe* effizient vermehren: mit Kindeln, die von der Mutterpflanze abfallen. Unter den rund 125 Arten ist die aus Madagaskar stammende *Kalanchoe blossfeldiana* am bekanntesten: Das Flammende Käthchen macht mit Blüten in satten Feuertönen seinem Namen alle Ehre. *Kalanchoe* sind Kurztagpflanzen, doch mit einem Gärtnertrick erblühen sie auch in der hellen Jahreszeit: einfach zur „Nachtruhe" frühabends in einen dunklen Karton stecken!

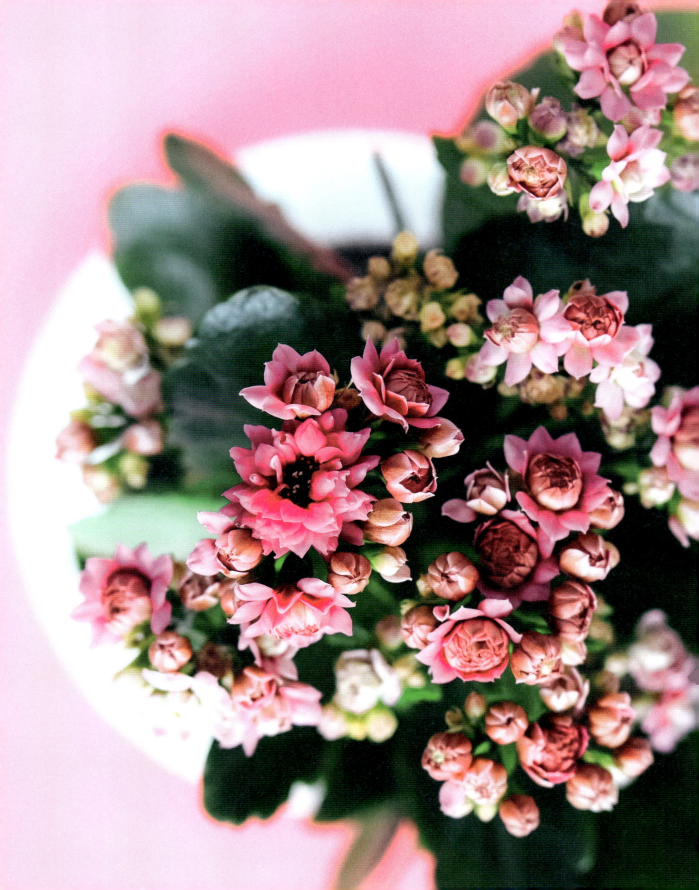

LEAF SUCCULENTS

Sansevieria trifasciata

SNAKE PLANT

EVERYONE'S FAVORITE MOTHER-IN-LAW

Hailing from desert parts of West Africa, *Sansevieria*, often called "snake plant" or "mother-in-law's tongue", must have been named by people whose spouses' moms had sharp tongues. No doubt the long leaves of this "bowstring hemp" taper to a sharp point. But there's no cause for alarm. *Sansevieria trifasciata* possesses enough refinement to polish the tarnished reputation of mothers-in-law. It makes no snide remarks, is robust and graceful, and is extremely low maintenance. It just sits in the living room.

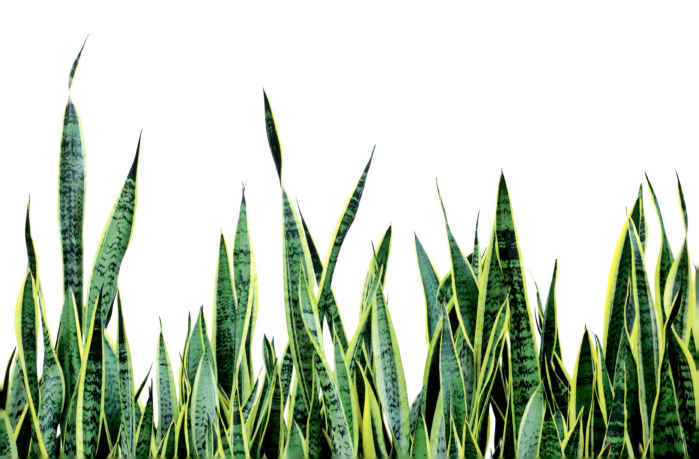

BLATTSUKKULENTEN

Sansevieria trifasciata

BOGENHANF

DIESE SCHWIEGERMUTTER IST ÜBERALL BELIEBT

Landläufig ist die aus Westafrikas Wüstengebieten stammende *Sansevieria* auch als Schlangenpflanze oder Schwiegermutterzunge bekannt – vermutlich, weil die langen, spitzen Blätter des Bogenhanfs mit dem Klischee von so manch scharfzüngigem Schwiegermutterkommentar verbunden werden. Doch keine Sorge, die gute *Sansevieria trifasciata* rettet mit ihrem robusten Naturell und der zugleich eleganten Erscheinung den Ruf aller Schwiegermütter: Im heimischen Wohnzimmer gibt sie sich äußerst anspruchslos und überhaupt nicht zickig.

LEAF SUCCULENTS

Sedum

STONECROPS AND ORPINES

GREEN ROOFS, POLLINATOR FRIENDLY, BEAUTIFUL IN AUTUMN: THE VERSATILITY OF *SEDUM*

Sedum, also known as stonecrop or orpine, is a champion among succulents native to the northern hemisphere, where more than 400 *Sedum* species are found. The smallest among them are mightiest when it comes to climate resilience. Low-growing species like *Sedum album* or *Sedum acre* can endure drought, heat, and even sub-zero temperatures remarkably well. These hardy plants, with their root systems, help stabilize loose slopes and enliven flat roofs as they form evergreen mats on minimal substrate so it's not too heavy. It's surprising to think that these masters of drought can also produce flowers that serve as a valuable resource for insects. Taller-growing species, such as *Sedum spectabile* and *Sedum telephium*, can produce even more magnificent flowers. The latter's flower clusters flourish on upright stems in bright hues ranging from yellow to purple, and they last well into autumn, standing like lighthouses in any bed or container.

RIGHT PAGE | Dry? Rocky? *Sedum acre* thrives where nothing else grows.

NEXT PAGE | Nutrient-poor soils stimulate magnificent, lush blooms in tall-growing species like *Sedum telephium* or *Sedum spectabile*.

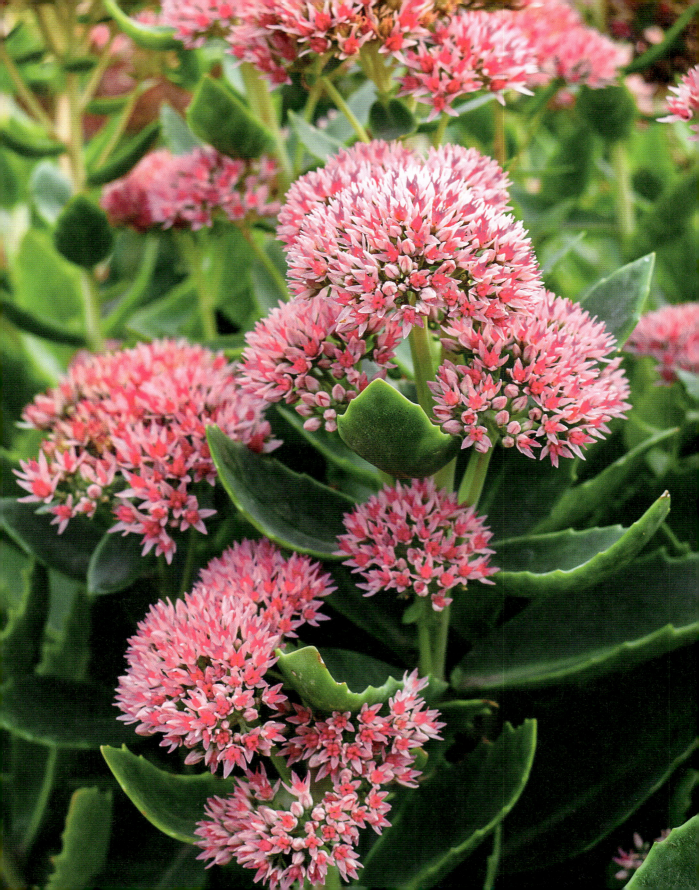

BLATTSUKKULENTEN

Sedum

MAUERPFEFFER UND FETTHENNE

DACHBEGRÜNUNG, BIENENWEIDE UND HERBSTSCHMUCK – SO VIELSEITIG SIND DIE VIELEN *SEDUM*-ARTEN

Sedum, im Volksmund Mauerpfeffer oder auch Fetthenne genannt, ist der Lokalmatador unter den Sukkulenten der nördlichen Hemisphäre. Über 400 Arten der Dickblattgewächse sind hier heimisch, und die Kleinsten unter ihnen sind die größten Klimahelden: Gerade die flach wachsenden Arten wie *Sedum album* oder *Sedum acre* halten Trockenheit, Hitze und sogar extreme Minusgrade bestens aus. Sie sichern mit ihrem Wurzelgewebe lockere Aufschüttungen an Böschungen und beleben als immergrüne Matten Flachdächer, die nur wenig Pflanzsubstrat tragen können. Kaum zu glauben, dass diese robusten Trockenkünstler auch noch Blüten hervorbringen, die Insekten eine wertvolle Nahrungsquelle sind …

Noch mehr Blütenpracht gelingt mit der Kombination von höherwachsenden Arten wie *Sedum spectabile* und *Sedum telephium*: Bei der Großen Fetthenne wachsen die Blütendolden an aufrechten Stängeln in leuchtenden Farben von Gelb bis Purpur – diese sind bis weit in den Herbst hinein blühende „Leuchttürme" in jeder Beet- oder Kübelbepflanzung.

VORIGE SEITE | Trocken? Felsig? Wo sonst nichts wächst, gedeiht *Sedum acre* bestens.

LINKE SEITE | Hochwachsende Arten wie *Sedum telephium* und *Sedum spectabile* werden von kargen Böden zu einer üppigen Blütenpracht angeregt.

LEAF SUCCULENTS

Sempervivum

HOUSELEEK

THE BOTANICAL NAME OF THE GENUS *SEMPERVIVUM* REVEALS A SMALL PARADOX

Sempervivum means "living forever". And the houseleeks, which grow in thick clusters like cushions, remain verdant and fresh even during the winter months. However, once one of its rosettes has bloomed, it withers away. The survival strategy of *Sempervivum* is thus to prolifically grow offshoots. Smaller, daughter rosettes sprout around the main rosette, mimicking chicks nestled under the protective feathers of a mother hen. It's a delightful image reflected in the English colloquial name, "hens and chicks".

HAUSWURZ

DER BOTANISCHE GATTUNGSNAME *SEMPERVIVUM* OFFENBART EIN KLEINES PARADOXON

Sempervivum bedeutet so viel wie „für immer lebend": Tatsächlich bleiben die in dicken Polstern wachsenden Hauswurze sogar im Winter frisch und grün. Sobald eine der Rosetten allerdings eine Blüte hervorgebracht hat, stirbt sie ab. Die Überlebensstrategie von *Sempervivum*: fleißig Ableger produzieren! Rund um die ursprüngliche Rosette wachsen wie Küken unter dem schützenden Gefieder einer Glucke kleine Tochterrosetten heran – ein schönes Bild, das sich im englischen Popularnamen *Hens and Chicks* widerspiegelt.

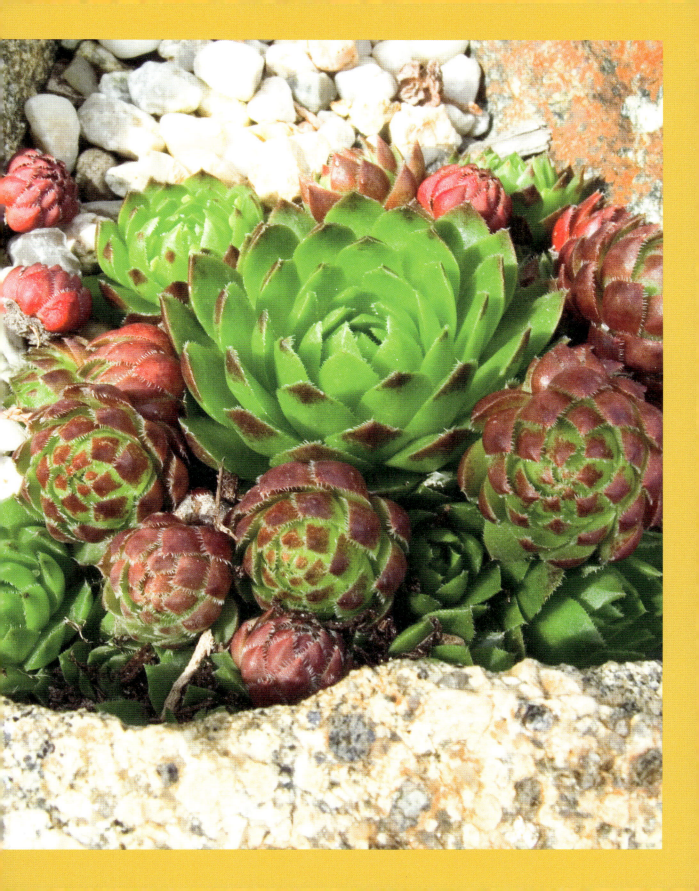

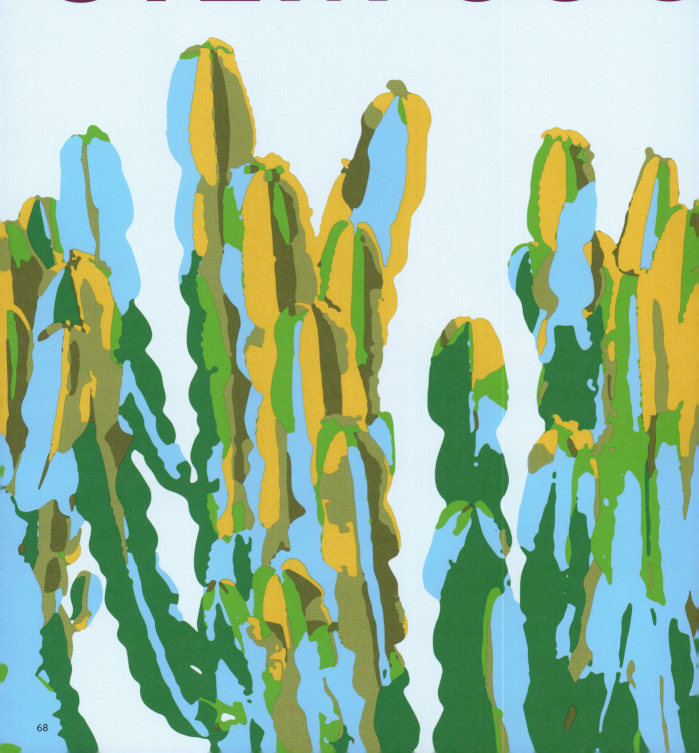

CULENTS

STAMM-SUKKULENTEN

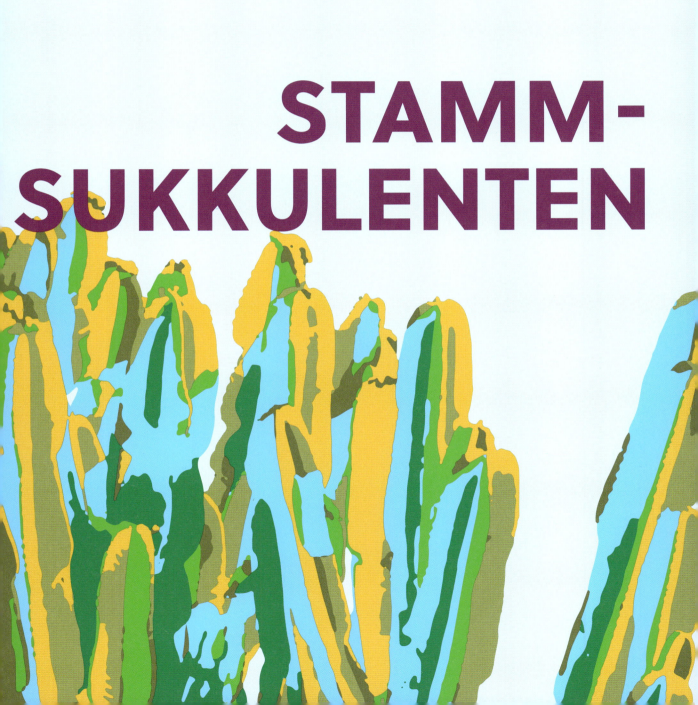

STEM SUCCULENTS

Stem succulents

THE GEOMETRY OF CACTUSES

SUCCULENT STEMS AT THEIR BEST

Virtually all cactuses are stem succulents, thereby making them the most prominent representatives of this group of succulents. Stem succulents, too, practice the principle of minimizing surface area to reduce evaporation. As a result, the leaves of many cactus species have either receded or are completely absent. Instead, photosynthesis occurs via the epidermis of the stem, and the stem itself is usually either cylindrical or spherical—a geometric solution to the problem of maximizing volume over surface area. The genus *Pachycereus*, for example, which is native to Mexico, reaches even deeper into the grab-bag of cactus tricks with its ribbed stem. The ribs increase the surface area available for photosynthesis, and yet each rib also provides shade for its neighbors. They are an impressive augmentation to the accordion effect that allow columnar cactuses to increase their volume.

RIGHT PAGE | Flowers of *Pachycereus pringlei* don't wait until day to open, thus attracting not only bees but even a particular species of bat.

RECHTE SEITE | Die Blüten der *Pachycereus pringlei* öffnen sich bereits nachts und locken so neben Bienen auch eine spezielle Fledermausart an.

STAMMSUKKULENTEN

Stammsukkulenten

DIE GEOMETRIE DER KAKTEEN

SUKKULENTE STÄMME IN BESTFORM

So gut wie alle Kakteenarten sind Stammsukkulenten und somit die prominentesten Vertreter dieser Sukkulentengruppe. Auch bei Stammsukkulenten gilt das Prinzip „Verdunstungsfläche minimieren" – und deshalb haben sich bei vielen Kakteenarten die Blätter zu Stacheln zurückgebildet oder fehlen ganz. Die Photosynthese übernimmt stattdessen die Außenhaut des Stamms: Dieser formt sich meist zylindrisch oder kugelförmig aus – nach dem geometrischen Prinzip „maximales Volumen, minimale Oberfläche". Die Gattung *Pachycereus* etwa, die in Mexiko heimisch ist, greift noch tiefer in die Trickkiste: Ihre prägnanten Rippen vergrößern zwar die Oberfläche für die Photosynthese, spenden sich aber auch gegenseitig Schatten – und erlauben den Säulenkakteen, ihr Volumen mit Ziehharmonikaeffekt eindrucksvoll zu erweitern.

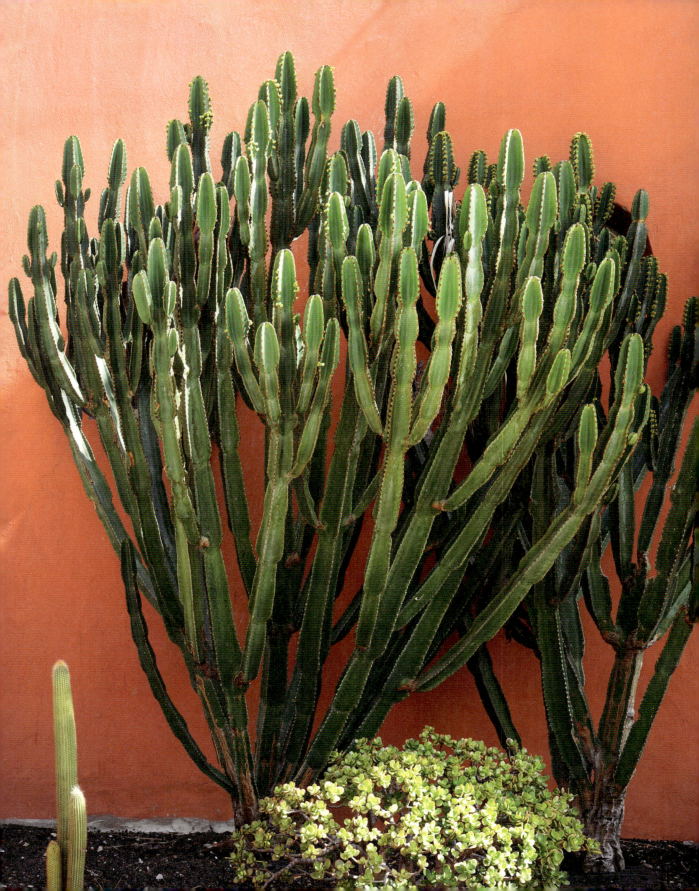

Euphorbiaceae

THE SPURGE FAMILY

OLD WORLD „CACTUSES" ARE NOT CACTUSES

Out of roughly 2000 described species in the spurge family, about a quarter count as stem succulents. Since their leaves are often no more than tiny thorns, *Euphorbiaceae* are commonly referred to as "old world cactuses". But it's only because cactuses are exclusively found in the "new world", that is, in the Americas (see p. 20). Despite the similarity, it is precisely these paired thorns that set species like Christ's thorn and Canary Island spurge apart from cactuses, which have spines that grow in clusters. One must remember that beauty is only skin deep with these spurges. Their milky, latex sap is toxic and can even cause chemical burns.

WOLFSMILCH-GEWÄCHSE

DIE „KAKTEEN DER ALTEN WELT" SIND GAR KEINE

Von den etwa 2000 bekannten Arten dieser Gewächse gelten rund ein Viertel als Stammsukkulenten. Weil deren Blätter oft zu kleinen Dornen reduziert sind, werden *Euphorbiaceae* gerne als „Kakteen der alten Welt" bezeichnet, da es Kakteen nur in der „neuen Welt", auf dem amerikanischen Kontinent gibt (siehe S. 21). Bei aller Ähnlichkeit sind es aber gerade diese in Paaren auftretenden Dornen, die Christusdorn, Kanaren-Wolfsmilch u. a. von Kakteen mit büschelweise wachsenden Dornen unterscheiden. Vorsicht gilt bei den „inneren Werten" von Wolfsmilchgewächsen: Ihr namensgebender milchiger Saft ist giftig und kann zu Verätzungen führen.

STEM SUCCULENTS

Asclepiadaceae: Stapelia gigantea, Hoya carnosa

MILKWEEDS

LOVELY BUT SMELLY

One of the succulents in Asclepiadaceae is *Stapelia gigantea*. Its grand, star-shaped flowers are beautiful. Its scent, however, is much less appealing. Due to its peculiar odor, it is often referred to as "carrion plant". *Hoya carnosa*, on the other hand, also known as "wax plant", is much more agreeable in terms of smell. Although the intense, sweet-ish scent of its flowers might not suit everyone's palate, the plants are considerate enough to only release it at night.

RIGHT PAGE | The giant flowers of *Stapelia gigantea* are 15 inches across or more when open.

NEXT PAGE | Artistic-looking, star-shaped flowers of *Hoya carnosa*, as though sculpted in wax

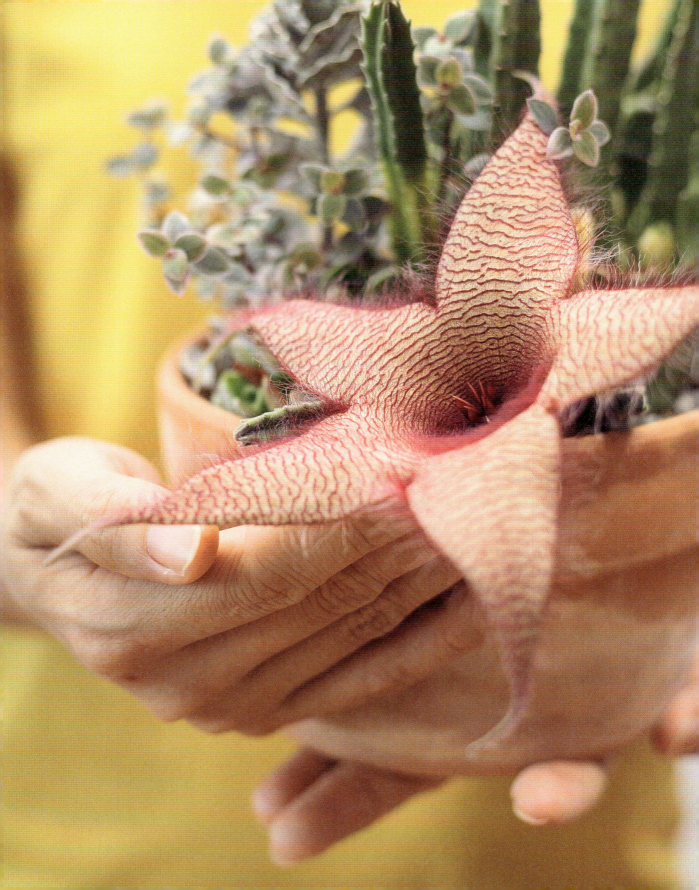

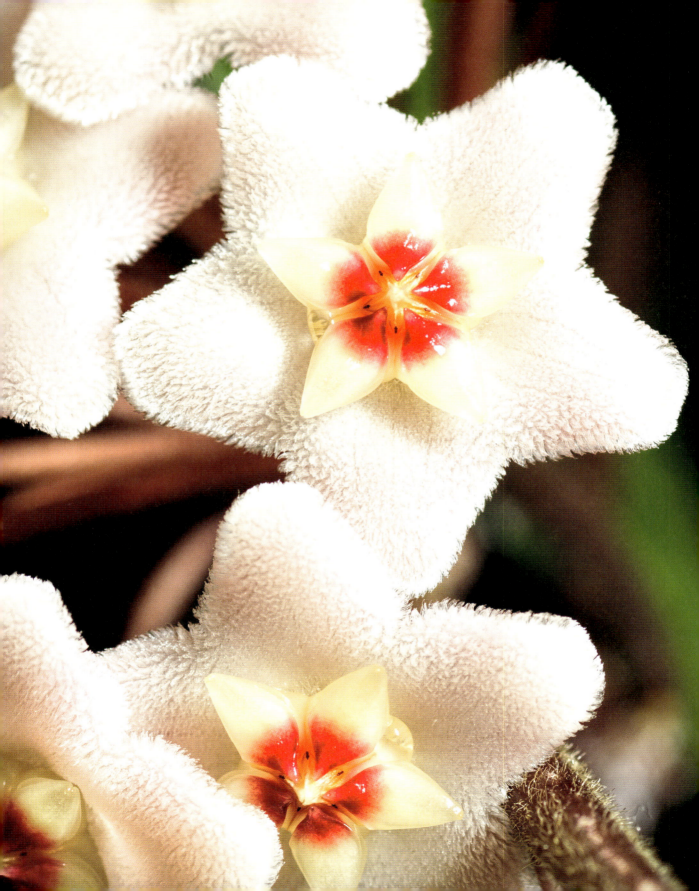

STAMMSUKKULENTEN

Asclepiadaceae: Stapelia gigantea, Hoya carnosa

SEIDENPFLANZEN-GEWÄCHSE

SCHÖN, ABER AUCH GANZ SCHÖN UNANGENEHM IM DUFT

Zu den sukkulenten Seidenpflanzengewächsen gehören Stapelia-Arten wie *Stapelia gigantea*. Deren sternförmige Blüten sind riesig und wunderschön, ihr Geruch lässt sie jedoch einiges an Attraktivität einbüßen: Nicht von ungefähr kommt der Volksname Aasblume. Da sind *Hoya carnosa*, auch Wachsblumen genannt, doch wesentlich angenehmer: Auch wenn ihr kräftiger, bisweilen süßlicher Duft nicht jedermanns Sache ist, verströmen ihn die Pflanzen zumindest nur nachts.

VORIGE SEITE | Bis zu 40 Zentimeter Durchmesser erreichen die Riesenblüten der *Stapelia gigantea*.

LINKE SEITE | Als wären sie aus Wachs geformt: kunstvolle Blütensterne der *Hoya carnosa*

STEM SUCCULENTS

Amaranthaceae: Sarcocornia & Salicornia

THE AMARANTH FAMILY

PICKLEWEED IS SUCCULENT—AND SALTY

There are also stem succulent species amongst the amaranth family. Best known are *Sarcocornia* and *Salicornia*. Their habitat in flat intertidal zones or subject to intermittent flooding requires significant robustness and salt tolerance. As such, its leaves have evolved into tiny scales. Pickleweed and its cousins instead invest in succulent stems that store enough water to maintain homeostasis for as long as possible in their salty environment. But if the end is near despite these adaptations, pickleweed goes out in a bright-red blaze.

While *Salicornia* species (these pages) are found in coastal areas of Northern Europe, *Sarcocornia fruticosa* (following pages) prefer saline soils along warmer coasts.

STAMMSUKKULENTEN

Amaranthaceae: Sarcocornia & Salicornia

FUCHSSCHWANZ-GEWÄCHSE

QUELLER & CO. – SUKKULENT UND SALZIG

Auch in der Familie der Fuchsschwanzgewächse *(Amaranthaceae)* gibt es stammsukkulente Arten: Den bekanntesten davon, *Sarcocornia* und *Salicornia*, fordert ihr Habitat im Wattbereich ein hohes Maß an Robustheit und Salztoleranz ab. So haben sich die Blätter zu kleinen Schuppen zurückgebildet, Queller & Co. konzentrieren sich auf die sukkulenten Sprossachsen: Hier helfen die Wasserspeicher, die Salzkonzentration in ihrem Inneren so lange es geht zu verdünnen. Wenn dann doch das Ende naht, färbt sich der Queller vor dem Absterben leuchtend rot.

Während *Salicornia*-Arten (diese Seite) vor allem im nordischen Küstenbereich anzutreffen sind, liebt *Sarcocornia fruticosa* (nächste Seite) salzige Böden in wärmeren Küstenregionen.

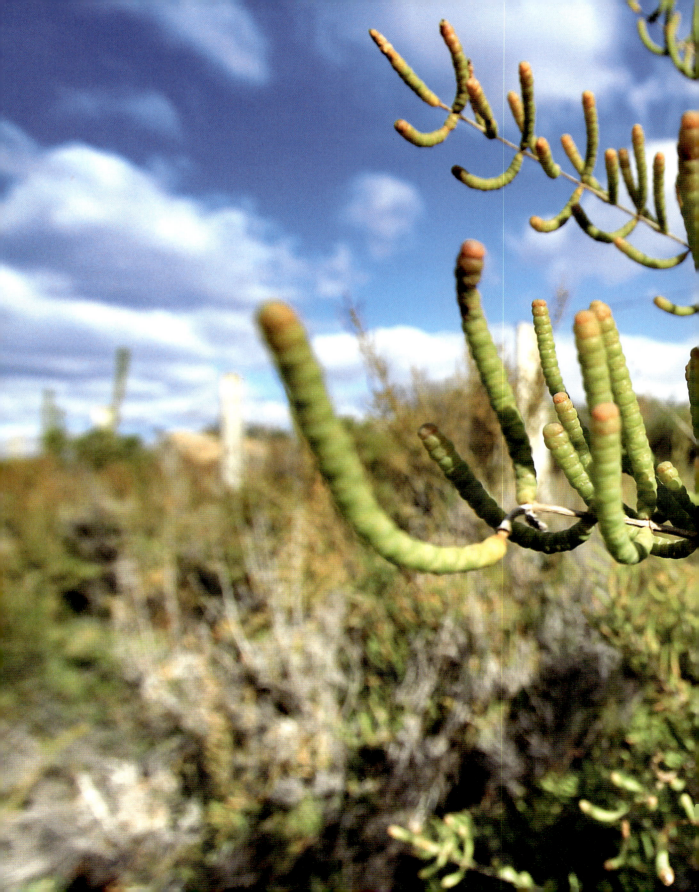

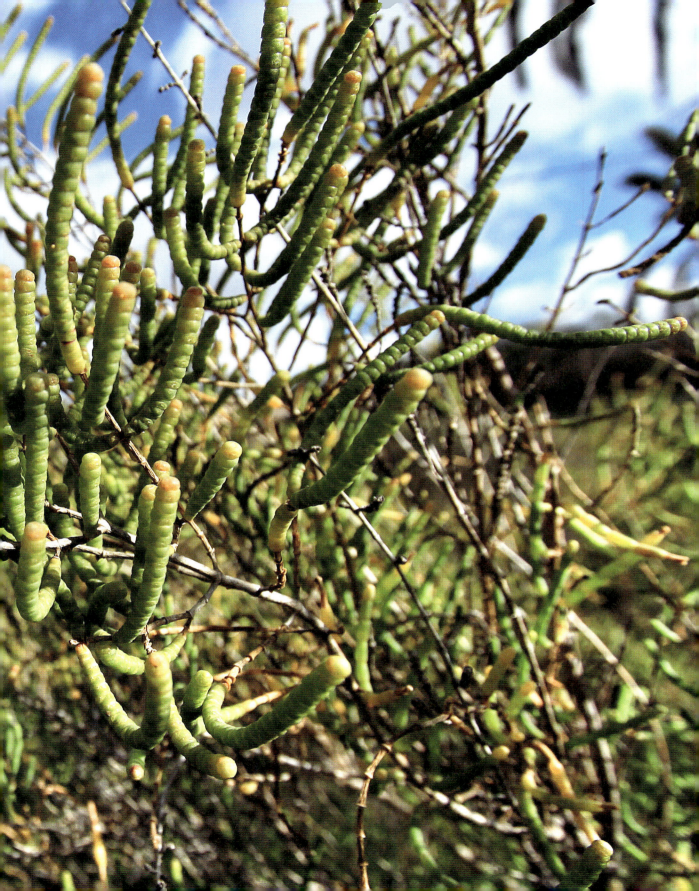

STEM SUCCULENTS

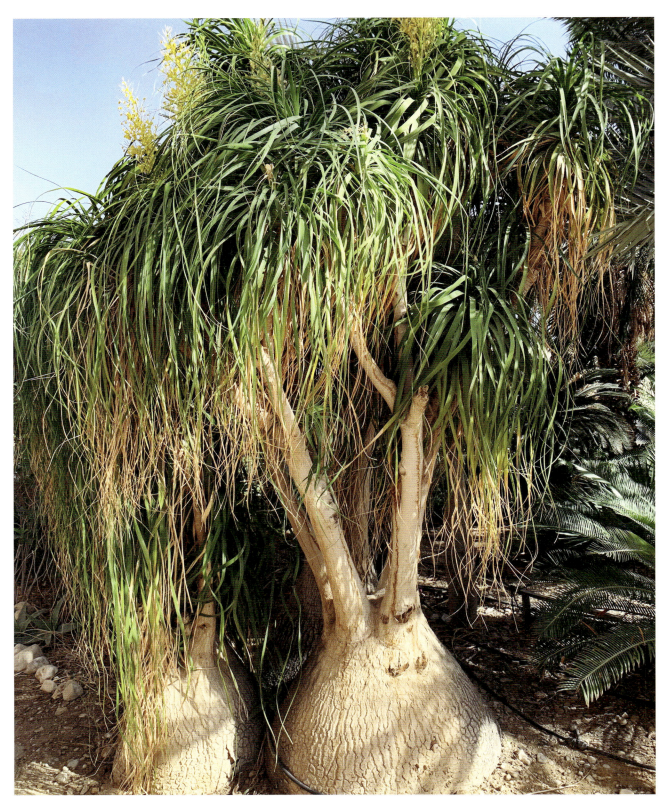

Beaucarnea recurvata

ELEPHANT'S FOOT

DOING WELL FOR ITSELF IN A DROUGHT

With its long stem and slender leaves, the *Beaucarnea recurvata* looks strikingly like a palm tree. In the wild in its native Mexico, this majestic stem succulent can grow to an imposing 30 feet tall. One look at the impressive, conical base of its trunk is insightful as to its common name of "elephant's foot". This structure's storage capacity allows this hardy succulent to live on water reserves during extended dry spells—making it particularly easy to care for even as a potted plant …

ELEFANTENFUSS

AUCH BEI TROCKENHEIT DICK IM GESCHÄFT

Mit ihrem langen Stamm und den schmalen Blättern erinnert die *Beaucarnea recurvata* an eine Palme. Stattliche neun Meter hoch wird die majestätische Stammsukkulente aus Mexiko in freier Natur. Ein Blick auf den unten eindrucksvoll verbreiterten Stamm erklärt den Popularnamen Elefantenfuß: Dank dieses vergrößerten Speichervolumens kann die robuste Sukkulente auch in langen Trockenperioden von Wasservorräten zehren – und gibt sich daher auch als Topfpflanze sehr pflegeleicht.

STEM SUCCULENTS

Brighamia insignis

CABBAGE ON A STICK

WHETHER PALM-TREE OR HEAD OF CABBAGE, THIS STEM SUCCULENT BEATS OUT ITS OWN RHYTHM

Brighamia insignis is often misleadingly nicknamed due to its unique appearance. Frequently it is referred to colloquially as the Vulcan palm, or as cabbage on a stick, because its leaves form cabbage-like rosettes. (Rest assured, its scent is much more pleasant.) *Brighamia insignis* is actually a member of the bellflower family, which shows from the distinctive shape of its flower. Unfortunately, this very shape also contributes to the vulnerability of the species. Only a specific Hawaiian moth can pollinate its six-inch-long flowers. Consequently, this stem succulent is now scarcely locatable in its natural habitat. However, efforts are being made in botanical gardens to preserve the species through hand pollination. Some enthusiasts who import a Vulcan palm to Europe may be in for a shock come spring. *Brighamia* tends to shed all its leaves just when all the surrounding plants are beginning to flourish, greening, and blossoming. But no worries: this Hawaiian lobelioid is simply recuperating from its winter vegetative growth. It is an unusual time of year for a plant to grow.

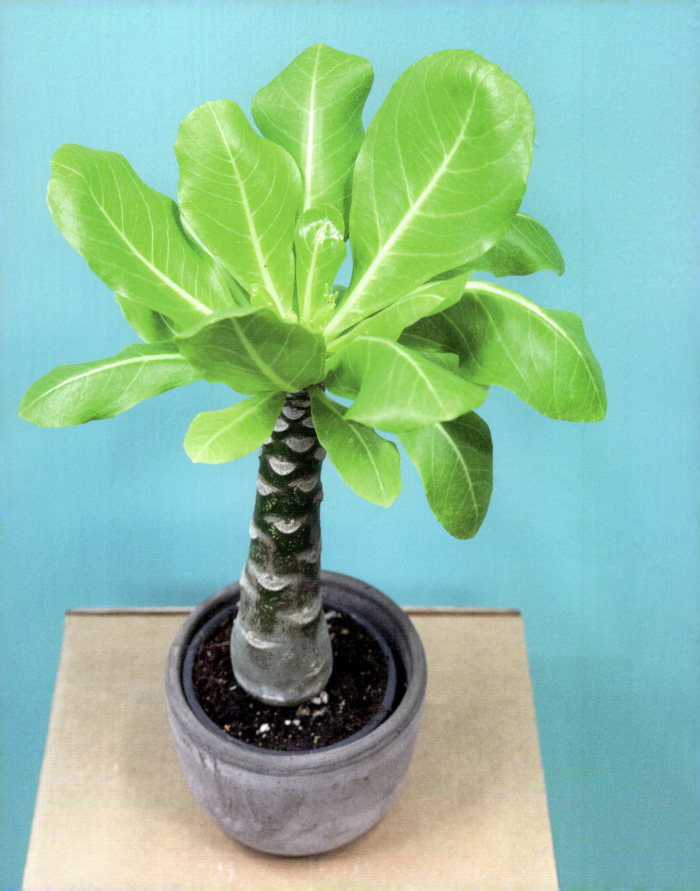

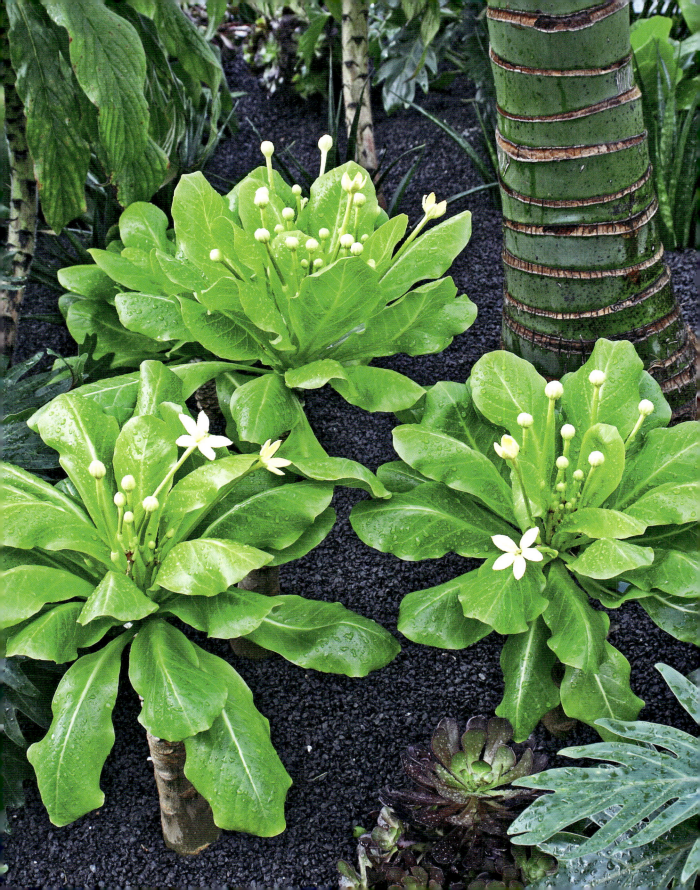

STAMMSUKKULENTEN

Brighamia insignis

HAWAII-PALME

PALME ODER KOHLKOPF? DIESE STAMMSUKKULENTE HAT IHREN EIGENEN RHYTHMUS …

Die *Brighamia insignis* trägt aufgrund ihres Aussehens einige irreführende Volksnamen: Oft als Hawaii-Palme bekannt, wird sie aufgrund ihrer kohlartigen Blattrosette im Englischen auch als *Cabbage on a Stick* bezeichnet – duftet aber deutlich angenehmer! Tatsächlich gehört *Brighamia insignis* zu den Glockenblumengewächsen. Die Blütenform offenbart diese Zugehörigkeit – und in ihr liegt auch der Grund, warum die Stammsukkulente leider stark existenzgefährdet ist: Nur ein einziger, auf Hawaii heimischer Falter kann zum Bestäuben ins Innere der rund 13 Zentimeter langen Blüten gelangen. In ihrem natürlichen Habitat ist die auch als Vulkanpalme bekannte *Brighamia insignis* deshalb leider kaum mehr anzutreffen, man versucht aber in botanischen Gärten, durch Bestäubung von Hand die Art zu erhalten. Holt man sich eine von außerhalb Europas importierte Hawaii-Palme als Zimmerpflanze ins Haus, erlebt so mancher Pflanzenfreund im Frühjahr erst einmal einen Schock: Die *Brighamia* wirft dann nämlich gerne alle Blätter ab – genau dann, wenn rundherum andere Pflanzen erst so richtig loslegen mit dem Grünen und Blühen! Doch keine Sorge: Die Hawaii-Palme ist nicht abgestorben, sie erholt sich nur von ihrer Wachstumsperiode, die ungewöhnlicherweise im Winter liegt.

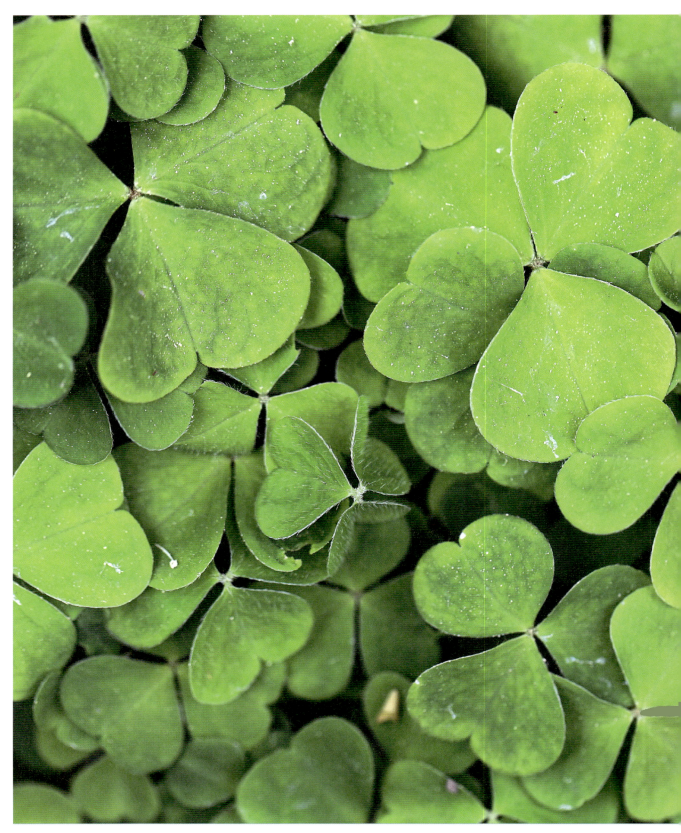

Succulent roots

HIDDEN CISTERNS

CLEVERLY STORING WATER UNDERGROUND

Though it isn't a common or obvious succulent adaptation, root succulence is an effective method of storing water. Certain genera for example, such as *Pelargonium* and *Oxalis*, have developed storage tissues in their roots, hidden beneath the ground. This not only helps in reducing water loss through evaporation but also serves as a defense mechanism against anything—especially animals—out for a meal. It's not always clear whether you're dealing with a true root succulent, though. "Caudiciform" plants, for example, have thickened main stems that function as storage organs located immediately above their root systems.

Sukkulente Wurzeln

VERBORGENE SPEICHER

CLEVER: WASSERVORRÄTE UNTER DER ERDE

Wurzelsukkulenz ist die seltenste und am wenigsten augenfällige Art, um Wasservorräte anzulegen – so befindet sich zum Beispiel bei einigen Arten von *Pelargonium* und *Oxalis* das Speichergewebe in den Wurzeln unter der Erde. Das schützt nicht nur vor Verdunstung, sondern auch vor Fraßfeinden – zumindest den tierischen. Ob echte Wurzelsukkulenz vorliegt, ist übrigens nicht immer leicht zu erkennen – man denke hier an *Caudex*-Pflanzen, deren Speicherorgan im Übergangsbereich von der Sprossachse zur Wurzel liegt.

SUCCULENT ROOTS

Pelargoniums with water reservoirs

SO LONG, WATERING

DON'T OVERWATER THIS FRAGRANT BEAUTY

When we think of *Pelargonium*, we often envision lush balcony displays of thirsty geraniums calling for diligent watering—mostly when our plant-crazed neighbors are away. So it's worth considering *Pelargonium sidoides* (right side) or *Pelargonium luridum* as great alternatives. These root succulents bloom just as beautifully as traditional geraniums, and they actually prefer slightly drier conditions thanks to their succulent root tubers. In its native southern Africa, the Zulu people have long prized *Pelargonium luridum* for medicinal and culinary uses.

Pelargonien mit Wasserspeicher

GIESSDIENST ADE

DUFTEND UND SCHÖN – UND NICHT VERSESSEN AUF STÄNDIGE BEWÄSSERUNG

Bei Pelargonien denken wir meist an üppige Balkonbepflanzungen und intensive Gießdienste, wenn die Pflanzen liebenden Nachbarn im Urlaub sind. Vielleicht wären hier *Pelargonium sidoides* (Bild rechts) oder *Pelargonium luridum* durchaus eine Empfehlung wert? Die Wurzelsukkulenten blühen mindestens genauso malerisch wie klassische Geranien und mögen es, den saftigen Wurzelknollen sei Dank, im Zweifelsfall lieber etwas trockener. Im südlichen Afrika, wo *Pelargonium luridum* und *Pelargonium sidoides* heimisch sind, nutzen die Zulu die Pflanze übrigens traditionell in Medizin und Küche.

WURZELSUKKULENTEN

SUCCULENT ROOTS

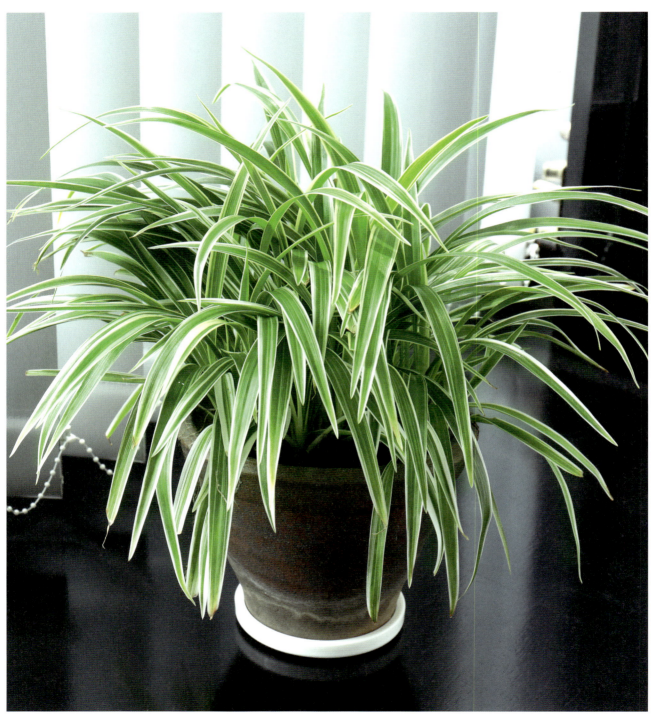

Chlorophytum comosum

COMMON SPIDER PLANT

HIDDEN TALENTS MAKE THIS ROOT SUCCULENT PERFECT FOR OFFICES AND OTHER SCENES OF NEGLECT

Many owners of the common spider plant are unaware that their windowsill adornment is a rare root succulent. The ability of *Chlorophytum comosum* to store water in its roots is what makes it a favorite office plant that can endure holiday closures, or an employee's annual leave, as their colleagues may not have the greenest of thumbs. Another remarkable quality of the common spider plant is its ability to filter pollutants, such as formaldehyde, from the air, making it an excellent companion for promoting a healthy office environment.

GRÜNLILIE

VERBORGENE TALENTE MACHEN DIESE WURZELSUKKULENTE PERFEKT FÜR BÜRO & CO.

Die wenigsten Grünlilien-Besitzer ahnen, eine der seltenen Wurzelsukkulenten auf der Fensterbank zu haben! Dass die Wurzeln von *Chlorophytum comosum* in der Lage sind, Wasser auf Vorrat einzulagern, macht sie zur beliebten Büropflanze: Sie überlebt auch den Jahresurlaub, wenn die Kollegen keinen grünen Daumen haben. Ein weiteres Talent der Grünlilie: Sie filtert Schadstoffe wie Formaldehyd aus der Raumluft – auch das macht sie zum perfekten grünen Helferlein für gesundes Büroklima.

Oxalis tuberosa

UQA

THIS ROOT SUCCULENT IS A PRIZED, NUTRITIOUS ANDEAN VEGETABLE

Oxalis tuberosa, with its charming, heart-shaped clover leaves (see p. 90), may be visually appealing. But its greatest treasure lies beneath the surface of the soil. Immediately after they are harvested, the vibrantly colored, reddish-yellow root tubers, known in Spanish as *oca*, are a rich source of water, carbohydrates, and vitamin C, which gives them a very sour flavor. After they've been stored and boiled, their flavor is milder. Those attempting to cultivate *oca* have to wait awhile for their harvest. It's a short-day plant that does not develop its storage tubers until autumn.

KNOLLIGER SAUERKLEE

DIESE WURZELSUKKULENTE WIRD IN DEN ANDEN ALS NAHRHAFTES GEMÜSE GESCHÄTZT

Mit seinen herzförmigen Kleeblättern (siehe S. 90) ist *Oxalis tuberosa* hübsch anzusehen, aber die wahren Schätze des Knolligen Sauerklees liegen unter der Erde verborgen: Direkt nach der Ernte sind die als *Oca* bekannten rot-gelben Wurzelknollen reich an Wasser, Kohlehydraten und Vitamin C und somit sehr sauer – beim Lagern und Kochen mildert sich der Geschmack. Wer sich im Anbau von *Oca* versucht, muss Geduld bis zur Ernte mitbringen: Als Kurztagpflanze bildet *Oxalis tuberosa* ihre Speicherknollen erst im Herbst aus.

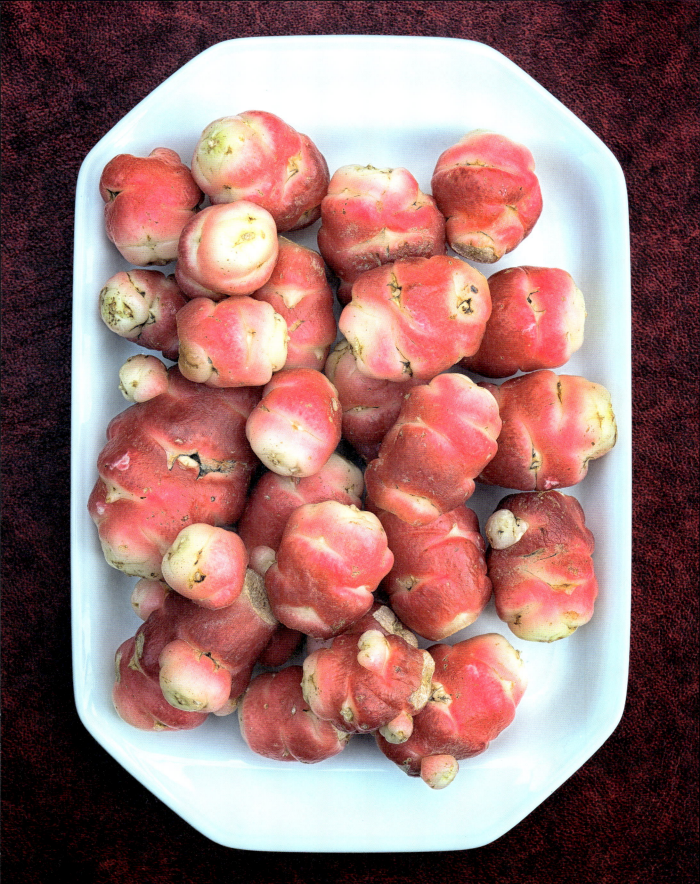

GIVING SUCCULENTS AS GIFTS

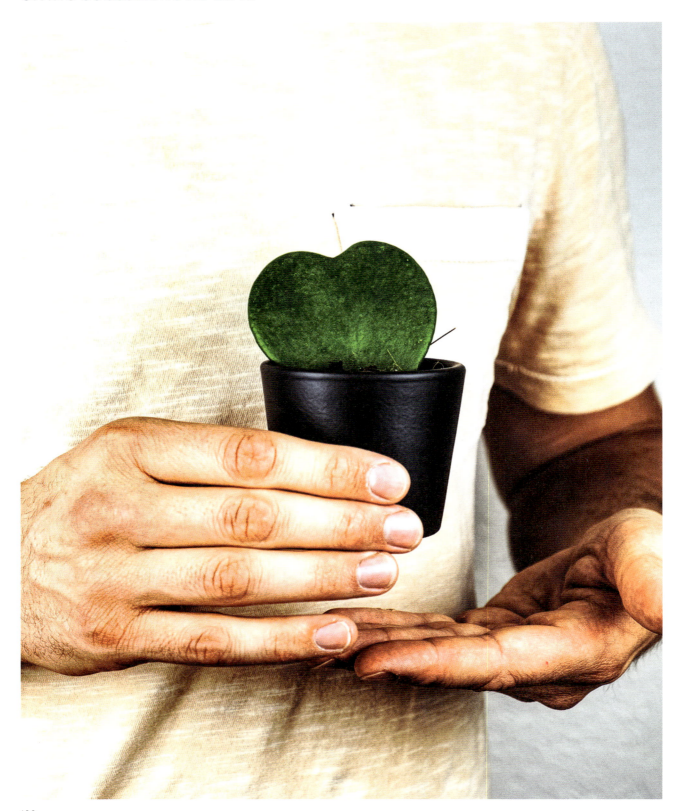

Hoya kerrii

THE JOY OF GIVING SUCCULENTS

SUCCULENTS MAKE YOU HAPPY. DOUBLE DOWN BY GIVING THEM AS GIFTS

Giving green gifts can bring joy both to the recipient as well as to the person doing the honors. If you wish to delight your loved ones with a succulent symbol of coming good fortune, consider a heart-shaped *Hoya kerrii* (left page) for romantic prospects or a money tree for prosperity. These easy-to-care-for succulents can symbolize good fortune and success on their own, with little input, giving a boost to inexperienced new plant owners.

DOPPELTE FREUDE

SUKKULENTEN MACHEN GLÜCKLICH – UND SUKKULENTEN SCHENKEN BRINGT GLÜCK

Grüne Geschenke bringen Freude: Dem Beschenkten zum einen – und auch die Schenkenden haben am Aussuchen des passenden Pflänzchens Vergnügen. Wer jemanden mit einem sukkulenten Glücksbringer erfreuen will, wählt zum Beispiel gerne die herzblättrige *Hoya kerrii* (Foto links) für Liebesglück oder den Geldbaum für Wohlstand. Für gutes Gelingen und Erfolg sorgen die pflegeleichten Sukkulenten ganz von selbst – und das spornt auch unerfahrene Neupflanzenbesitzer an.

GIVING SUCCULENTS AS GIFTS

Crassula ovata

FOR A POSITIVE OUTLOOK

WITH ITS ROUND LEAVES, THE MONEY TREE IS CONSIDERED A SYMBOL OF PROSPERITY AND SUCCESS IN ASIA AND BEYOND

In Asia, it's customary to receive a money tree on opening a business. This lucky charm, traditionally placed at the entrance, will invite good fortune. Feng shui includes precise guidelines for what symbolic influence this shrub-like succulent will exert depending on where it is in the house. To the west, it is believed to bring blessings for children. To the northwest, it's thought to attract supportive allies. Place it to the southwest, and the plant is said to foster wealth within the house. If positioned to the east, it is expected to inspire health and harmony within the family.

BESTE AUSSICHTEN

MIT SEINEN RUNDEN BLÄTTERN GILT DER GELDBAUM NICHT NUR IN ASIEN ALS SYMBOL FÜR WOHLSTAND

Wer in Asien zur Eröffnung eines Geschäfts einen Geldbaum geschenkt bekommt, platziert diesen Glücksbringer traditionell am Eingang, um für gutes Gelingen zu sorgen. Im Feng-Shui gibt es genaue Anleitungen, welche Symbolkraft die Strauchsukkulente je nach Platzierung im Haus hat: Nach Westen gerichtet soll sie Kindersegen bringen, im Nordwesten für hilfreiche Unterstützer sorgen. Südwestlich platziert soll die Pflanze Wohlstand im Haus bewirken und im Osten Gesundheit und Harmonie in der Familie heraufbeschwören.

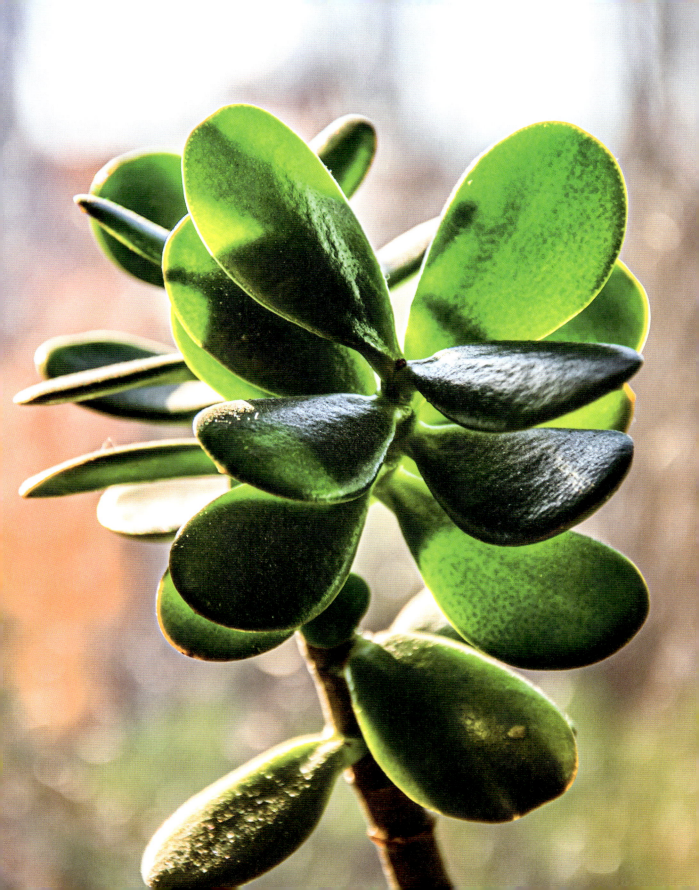

GIVING SUCCULENTS AS GIFTS

The language of succulents

SUCCULENT SYMBOLISM

WHEN PLANTS SPEAK LOUDER THAN WORDS

When one considers them as potential gifts, it's useful to know that numerous succulents other than money trees are laden with symbolism. In their natural habitat, succulents demonstrate enduring resilience. This predestines them to represent enduring friendship that can stand the test. *Aloe vera* is linked especially to health and good fortune, likely due to its historic use in traditional medicine. With its sword-like leaves, the steadfast agave is viewed as a symbol of security.

Spiny cactuses are believed to repel bad energy and, much like the *Euphorbia* species Christ's thorn, are seen as symbols of courage and protection on one hand, but also of purity and chastity. The vibrant colors of its durable flowers make the flaming Katy a representative of passion.

And given that traditional folk wisdom ascribes to the common houseleek the power to ward off lightning and misfortune, they make a perfect housewarming gift, as tokens of good luck.

Die Sprache der Sukkulenten

SUKKULENTEN MIT SYMBOLIK

WENN PFLANZEN MEHR ALS WORTE SAGEN

Neben dem Geldbaum werden auch viele andere Sukkulenten mit symbolischer Bedeutung verbunden – gut, beim Verschenken darüber Bescheid zu wissen! In ihren natürlichen Lebensräumen erweisen sich Sukkulenten als ausdauernd und widerstandsfähig – und sind so geradezu prädestiniert, um als Symbol von Freundschaft zu gelten, die lange währt und Herausforderungen überdauert. *Aloe vera* speziell wird auch mit Glück und Gesundheit in Verbindung gebracht, vermutlich aufgrund ihrer langjährigen Verwendung in der Volksmedizin. Mit ihren schwertartigen Blättern gilt die wehrhafte Agave als Symbol für Sicherheit.

Dornige Kakteen sollen negative Energien abwehren und gelten, ähnlich der *Euphorbia*-Art Christusdorn, als Symbol für Mut und Schutz, aber auch für Reinheit und Keuschheit. Dass das Flammende Käthchen hingegen für leidenschaftliche Liebe steht, verraten schon die feurigen Farben seiner ausdauernden Blüten.

Und da Dachwurzen nach altem Volksglauben das Haus vor Blitzschlag und Unheil beschützen, sind sie perfekt als glücksbringendes Geschenk zum Einzug in ein neues Heim geeignet.

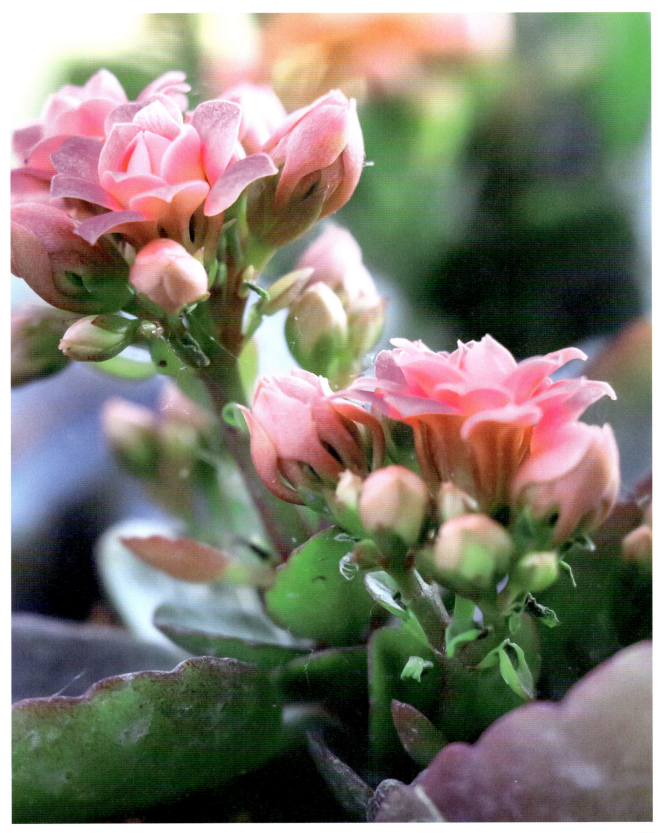

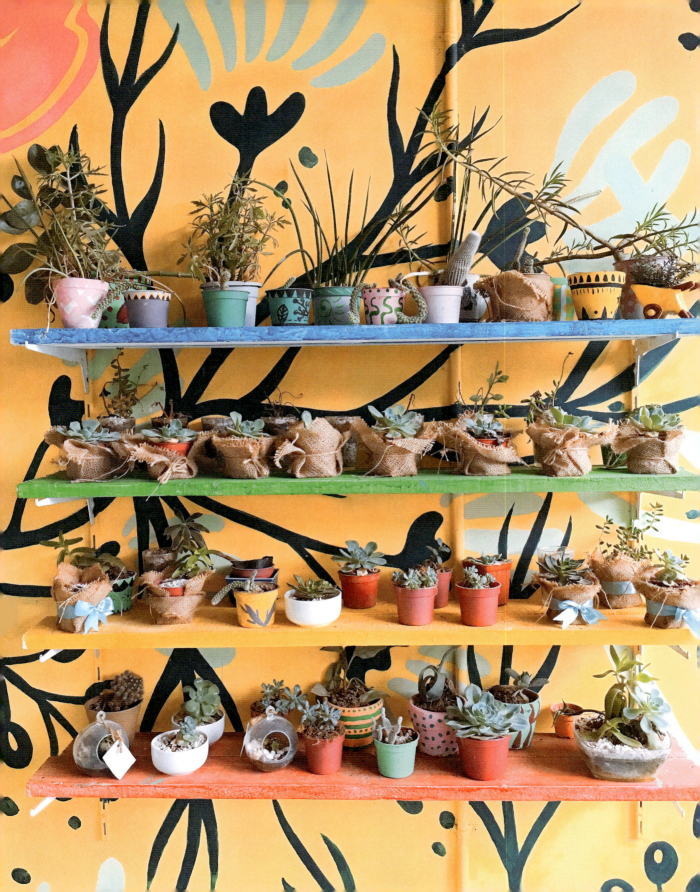

WOHNEN MIT SUKKULENTEN

Succulents trending

PLANTS CAUGHT IN THE ZEITGEIST

WHETHER IN CAFÉS OR STYLISH APARTMENTS, SUCCULENTS AND CACTUSES HAVE BECOME INEVITABLE

When it comes to houseplants, succulents have been enjoying a notable surge in popularity in recent years. But how have these once-niche plants suddenly become the must-have of every modern space? The answer is simply that they align perfectly with contemporary life. Vibrant, diverse, and low maintenance, they add a touch of style at virtually no effort. So it's no surprise that they have made the leap from being grandma's potted plant to a trendy home accessory.

Sukkulenten im Trend

PFLANZEN IM ZEITGEIST

AUS SZENECAFÉS UND STYLISCHEN ALTBAUWOHNUNGEN SIND SIE NICHT MEHR WEGZUDENKEN

Was Zimmerpflanzen angeht, zeigt das Zeitgeistbarometer der letzten Jahre bei Sukkulenten steil nach oben. Doch wie kommt es, dass Pflanzen, die lange ein Nischendasein gefristet haben, plötzlich in aller Munde und in allen Wohnzimmern sind? Ganz einfach: Sie passen perfekt zum Leben von heute. Sie sind bunt, vielfältig und unkompliziert – und schaffen es dabei auch noch, stylish auszusehen. Kein Wunder, dass ihnen der Wandel von Omas Topfpflanze zum coolen Wohnaccessoire gelungen ist.

Frugal with water

EASY TO LIVE WITH

IF YOU MIGHT NOT WATER FOR WEEKS ON END, THESE PLANTS ARE FOR YOU

Watering is outmoded. Succulents are the answer to all the prayers of frequent travelers on long trips. They are also ideal for horticultural newbies who are still cultivating their green thumb. Succulents have a way of signaling when they're desperate for water. Once they have depleted their internal stores, their otherwise typically plump leaves start to wither. So don't feel guilty about underwatering your succulent. Overwatering is what irks them. It's caused many a near-drowning, as all succulent owners will hopefully realize.

Genügsam mit Wasser

UNKOMPLIZIERTE MITBEWOHNER

EINE PFLANZE, DIE ES AUCH NICHT ÜBELNIMMT, WENN SIE WOCHENLANG NICHT GEGOSSEN WIRD?

Gießdienst ade: Für alle, die gerne oft und lange in den Urlaub fahren, sind Sukkulenten die Erhörung ihrer Gebete! Auch für Botanikeinsteiger, die ihren grünen Daumen erst noch kultivieren müssen, sind die Dickblattgewächse ideal. Sie zeigen von selbst an, wann sie dringend wieder Wasser brauchen: Sind die inneren Speicher erschöpft, werden die sonst prallen Blätter schlaffer. Einen Fehler nehmen sie jedoch übel – so manche Sukkulente wurde aus lauter schlechtem Gieß-Gewissen im Nachhinein fast ertränkt …

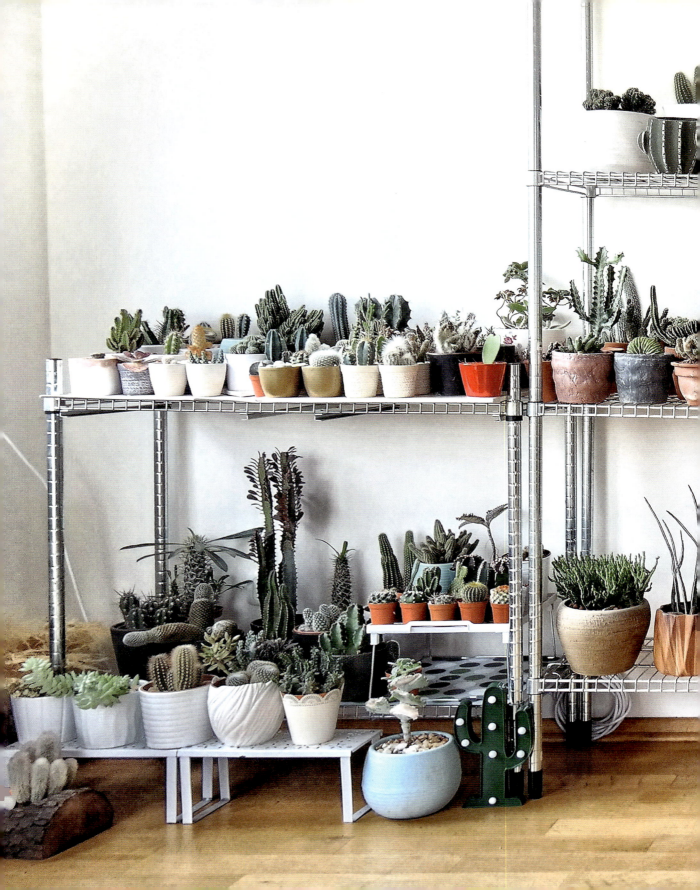

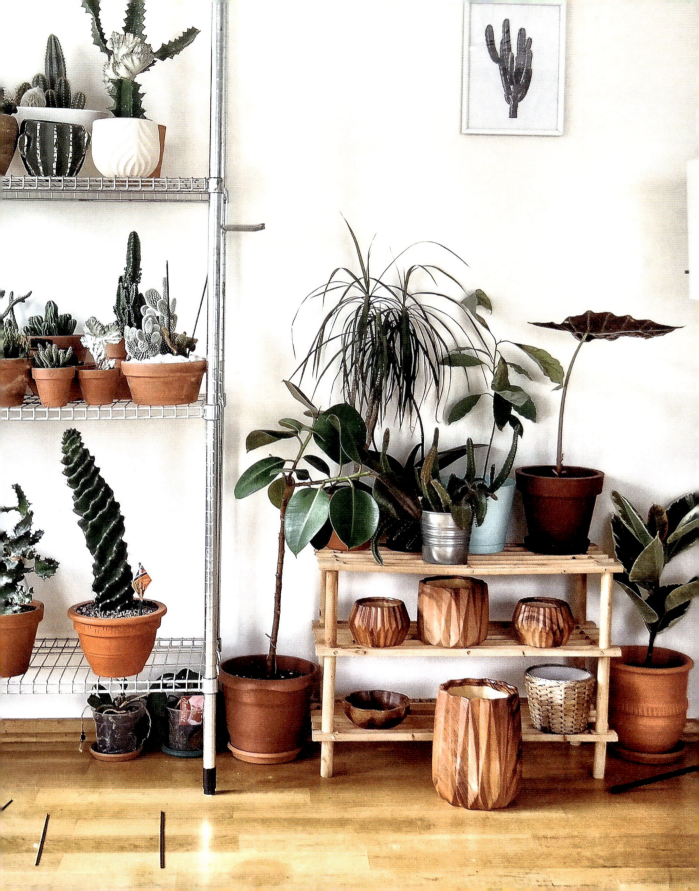

LIVING WITH SUCCULENTS

Succulents for better air quality

A WONDERFUL ATMO-SPHERE IN EVERY ROOM

THEIR APPETITE FOR CO_2 MAKES SUCCULENTS DECORATIVE PLANT-BASED AIR FILTERS

Scientific evidence, dating back to a NASA study in the 1980s, supports the conclusion that succulent houseplants serve as effective air purifiers. Especially snake plant, spider plant, and *Aloe vera* are adept at filtering pollutants like formaldehyde, toluene, and ammonia from the air, while also helping to trap fine dust particles, making them excellent companions not only in our homes but also in offices. They also provide us with fresh oxygen and will do it contently even from a dim corner.

Aloe vera not only filters pollutants from the air, it's also a nighttime producer of oxygen—the perfect houseplant.

WOHNEN MIT SUKKULENTEN

Sukkulenten als Luftverbesserer

PRIMA KLIMA IN JEDEM ZIMMER

IHR APPETIT AUF CO_2 MACHT SUKKULENTEN ZU DEKORATIVEN LUFTFILTERN AUF PFLANZLICHER BASIS

Spätestens seit einer NASA-Studie aus den 1980er-Jahren ist es wissenschaftlich belegt: Sukkulente Zimmerpflanzen leisten als Luftverbesserer gute Dienste. Gerade Bogenhanf, Grünlilie und *Aloe vera* filtern Schadstoffe wie Formaldehyd, Toluol und Ammoniak aus der Luft und binden Feinstaub – das macht sie nicht nur in Wohnräumen, sondern auch in Büros zu wertvollen Mitbewohnern. Die fleißigen Sukkulenten versorgen uns zudem mit neuem Sauerstoff – und das, obwohl sie sich auch mit dunklen Ecken begnügen …

Aloe vera bindet nicht nur Schadstoffe in der Raumluft, sondern produziert auch nachts fleißig Sauerstoff – perfekt als Schlafzimmerpflanze!

LIVING WITH SUCCULENTS

Succulents as home accessories (1)

LIVING IN STYLE

SOFT COLORS, STRIKING SHAPES: SUCCULENTS EMBODY THE STUFF OF DESIGN

Whether pointy like *Sansevieria* or *Haworthia*, knobby like *Crassula ovata* and *Lithops*, or developing fascinating, mandala-like rosettes like *Echeveria* and *Sempervivum*, the diversity of succulents contributes to their popularity as design objects. Their clean, minimalist shapes, coupled with their leaf surfaces that can range from smooth and glossy to velvety and matte, effortlessly complement modern interior design trends. Whether it's a pared-down Scandinavian look, monochromatic minimalism, or a charismatic retro vibe, a succulent's soft gradations of color between pale green and delicate violet always win.

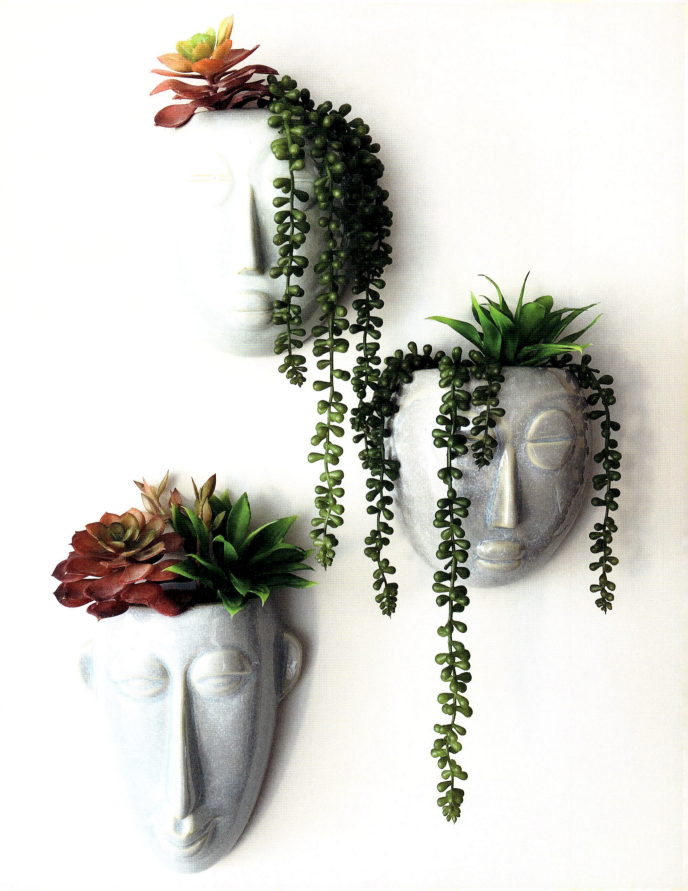

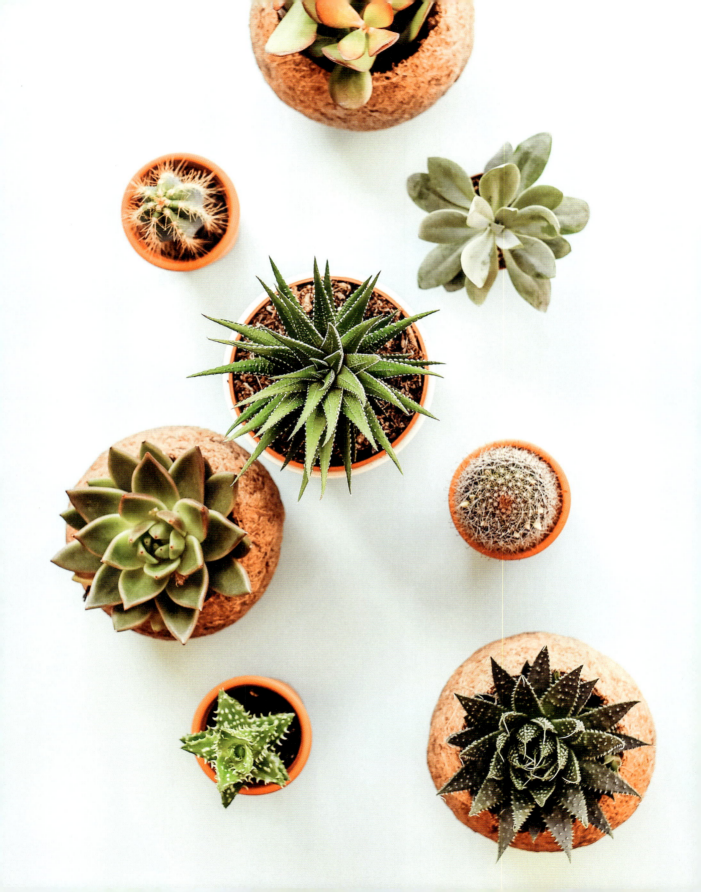

WOHNEN MIT SUKKULENTEN

Sukkulenten als Wohnaccessoires (1)

GANZ SCHÖN STYLISH

SANFTE FARBEN, KLARE FORMEN – SUKKULENTEN HABEN DAS ZEUG ZUM DESIGNOBJEKT

Zackig wie *Sansevieria* und *Haworthia* oder knubbelig wie *Crassula ovata* und *Lithops*? Oder die faszinierenden Rosetten von *Echeveria* und *Sempervivum*, die wie Naturmandalas anmuten? Ihre Vielfalt macht Sukkulenten zu beliebten „Designerpflanzen". Ihre klaren, einfachen Formen mit mal glänzend-glatten, mal samtig-matten Blattoberflächen ergänzen moderne Wohntrends perfekt. Ob reduzierter Scandi-Style, monochromer Minimalismus oder charaktervolle Retro-Looks: Die sanften Farbnuancen von Blassgrün bis zu zartem Violett überzeugen immer.

Succulents as home accessories (2)

GREENERY IN SMALL SPACES

THERE'S ALWAYS SPACE FOR A DELIGHTFUL SUCCULENT

No matter how limited the space, a lively collection of pots housing *Echeveria*, *Sansevieria*, and other succulents creates a green mini oasis in the smallest apartment. With urban rents on the rise, it's a solid proposition. Besides, the beauty of leaf succulents is that most are niche plants that can thrive even in low-light conditions. For instance, *Senecio rowleyanus* gracefully drapes its green strings of pearls downwards, making it the perfect choice for that dark top-corner shelf.

Sukkulenten als Wohnaccessoires (2)

GRÜNE MINIOASEN

KLEIN UND FEIN – FÜR SUKKULENTEN FINDET SICH ÜBERALL EIN PLÄTZCHEN!

Raum ist in der kleinsten Hütte: Mit einem bunten Sammelsurium an Pflanztöpfen von *Echeveria*, *Sansevieria* & Co. hat eine grüne Minioase auch in der kleinsten Wohnung Platz – in Zeiten horrender Großstadtmieten ein schlagendes Argument! Außerdem sind die meisten Blattsukkulenten perfekte Nischenpflanzen, die mit wenig Licht zurechtkommen. Selbst wenn nur noch die dunkle Ecke oben auf dem Regal frei ist, lässt etwa *Senecio rowleyanus* ihre grünen Perlschnüre nach unten ranken.

WOHNEN MIT SUKKULENTEN

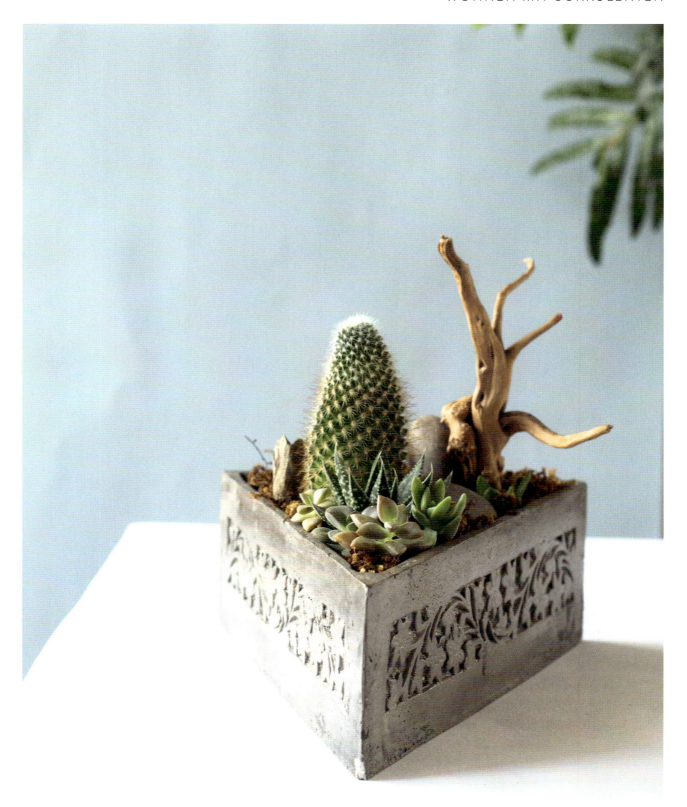

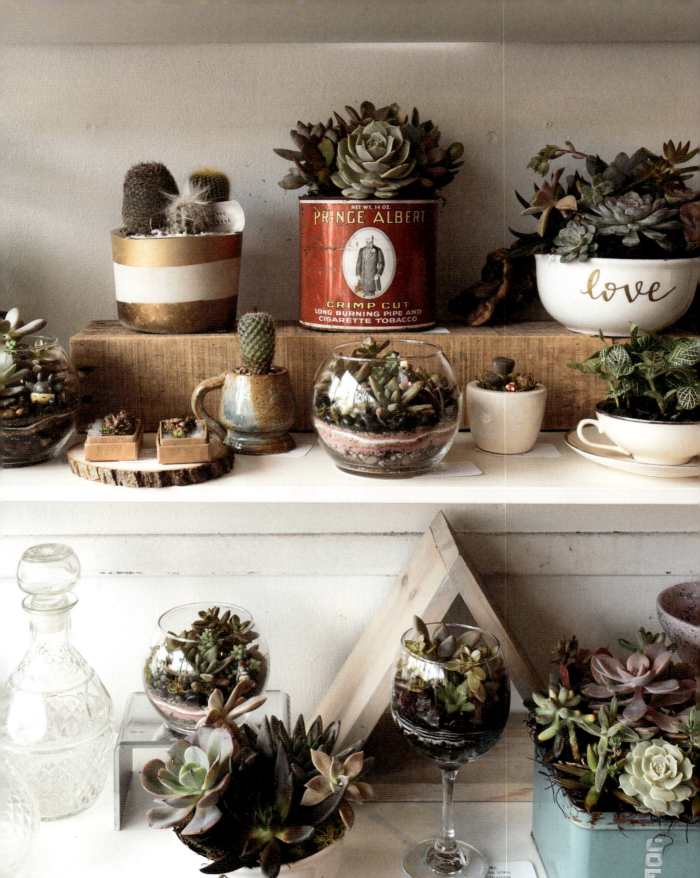

Decorative and budget-friendly

CREATIVE PLANTERS

THERE'S A LID FOR EVERY POT—UNLESS A SUCCULENT MOVES IN

With the upswing in upcycling, succulents create an opportunity to breathe new life into everyday household items by repurposing them as planters. Old tin cans, worn-out pans, grandma's teapot, a chipped favorite mug—you name it—with a succulent, these unconventional containers can become focal points. Upcycling is perfect for allowing us to express our creativity while saving resources, and it makes collecting succulents an affordable hobby that can be enjoyed on tight purse strings.

Dekorativ & günstig

KREATIVE PFLANZGEFÄSSE

JEDER TOPF FINDET SEINEN DECKEL – UND MANCHMAL EINE SUKKULENTE ALS NEUEN BEWOHNER ...

Upcycling liegt im Trend – und mit Sukkulenten lässt sich so manchem Haushaltsgegenstand als Pflanzgefäß neues Leben einhauchen. Ob alte Konservendosen, ausgediente Backformen, leicht angeschlagene Lieblingstassen oder Omas Teekanne: Mit außergewöhnlichen Pflanzgefäßen werden Sukkulenten zum Blickfang. Perfekt: Wiederverwertung schont Ressourcen – und so wird die Sukkulenten-Sammelleidenschaft auch zum Hobby für den kleinen Geldbeutel.

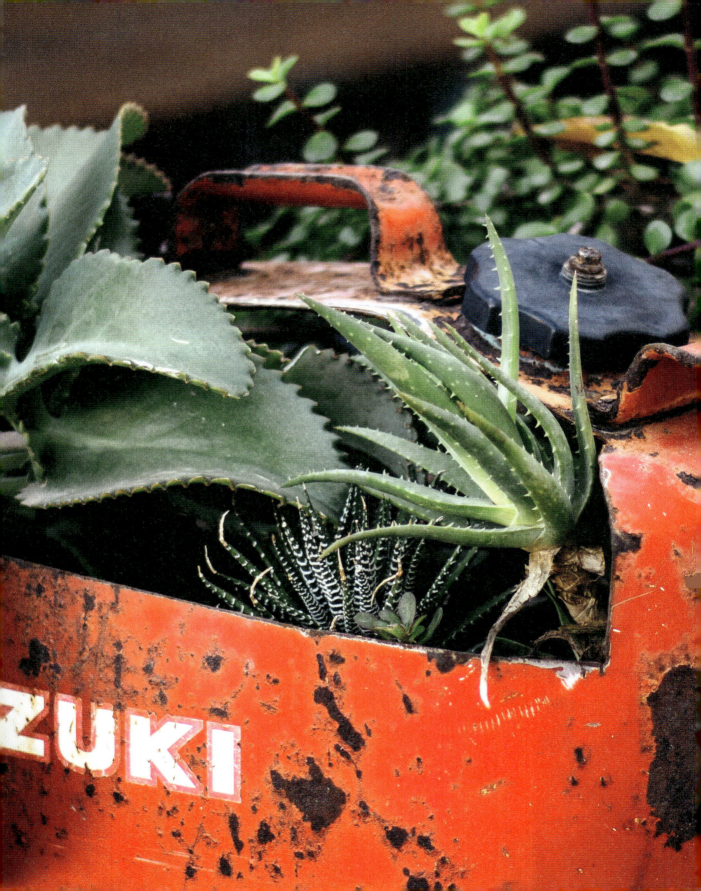

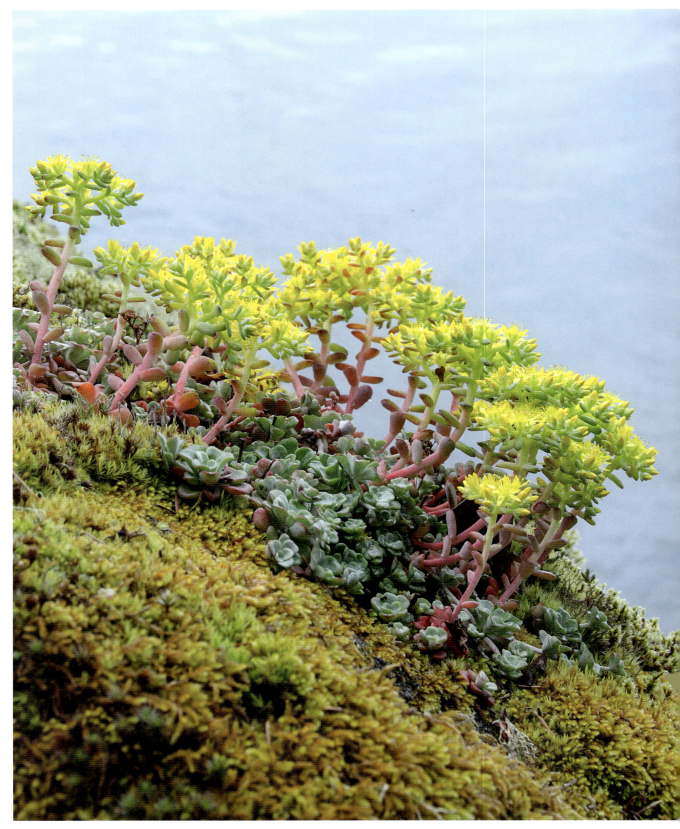

Plant poachers and Dudleya farinosa

HYPE-BASED ENDANGERMENT

A GROWING PROBLEM OF POPULARITY

Several succulents are so coveted that they now face extinction. Once abundant, these plants have become highly sought-after collector's items that can fetch exorbitant prices thanks to social media. For slow-growing cactuses that reach impressive sizes only over time, horticultural breeding is costly and time-consuming. But it's the faster-growing succulents that are at greatest risk of being pilfered from their natural habitats, particularly in regions like North America or South Africa. A thriving black market caters to an insatiable demand for these prized succulents, especially in Asia, where one may find an unbounded passion for collecting them.

Even species like *Dudleya farinosa*, which used to flourish along California's coasts, has been harvested so ruthlessly that it is now considered endangered. Strict laws have been implemented to combat *Dudleya* poaching, with hefty fines of up to half a million dollars. Authorities in South Africa are also cracking down on poaching, striving to protect the native succulent population. Unfortunately, many of the plundered wild succulent captives face short lifespans as houseplants since they are accustomed to different environmental conditions.

WOHNEN MIT SUKKULENTEN

Pflanzen-Wilderer und Dudleya farinosa

VOM HYPE BEDROHT

IM FAHRWASSER DES ANHALTENDEN SUKKULENTEN-TRENDS ENTSTEHT EIN WACHSENDES PROBLEM

Etliche Sukkulentenarten gelten mittlerweile als gefährdet, da sie durch Social-Media-Hypes zu gesuchten Sammlerstücken mit horrenden Preisen avanciert sind. Bei Kakteenarten, die ein hohes Alter erreichen und nur langsam zu stattlicher Größe heranwachsen, ist die gärtnerische Zucht aufwendig und langwierig. Bei schneller wachsenden Sukkulenten ist es schlichtweg zu einfach, diese etwa in Nordamerika und Südafrika aus der Natur zu rauben. Der Schwarzmarkt boomt: Die begehrten Sukkulenten werden in großer Zahl nach Asien verkauft, wo die Sammelleidenschaft keine Grenzen kennt.

Auch die bis vor einigen Jahren üppig an Kaliforniens Küste wachsende *Dudleya farinosa* wurde so rücksichtslos abgeerntet, dass sie als gefährdet gilt. Inzwischen gibt es strenge Gesetze, die bis zu eine halbe Million Dollar an Strafe für *Dudleya*-Wilderer vorsehen. Auch in Südafrika greifen die Behörden hart gegen den illegalen Raubbau durch, in der Hoffnung, die natürliche Sukkulentenpopulation bewahren zu können. Den geplünderten Wildsukkulenten ist als Zimmerpflanzen oft leider nur ein kurzes Leben beschieden, da sie an andere Umweltbedingungen gewöhnt sind.

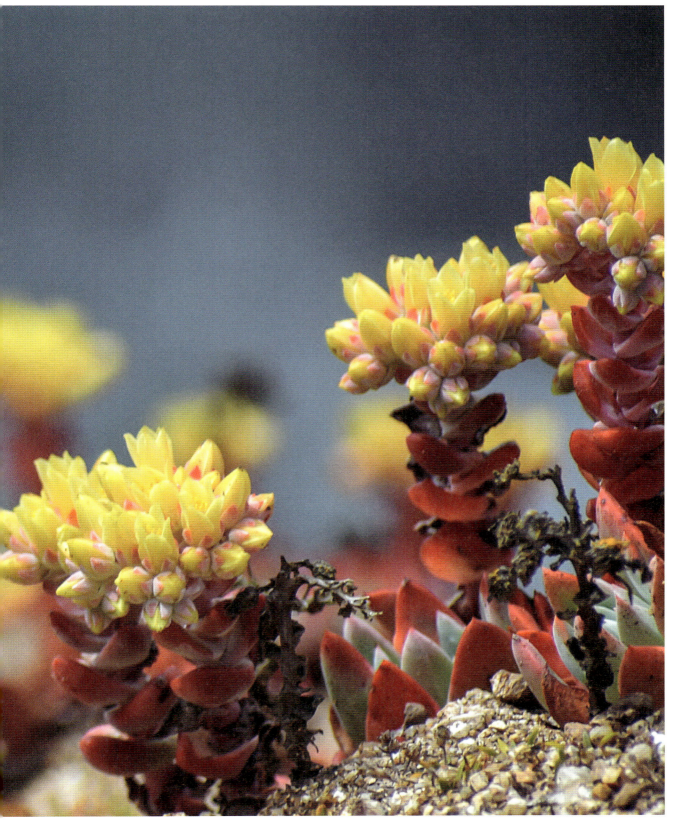

MEDICINE & COSMETICS

Aloe vera & Sempervivum

HEALING WITH SUCCULENTS?

SUCCULENTS ARE INDISPENSABLE MEDICINALS WHEN THE APOTHECARY IS MOTHER NATURE

Succulents have been treasured in traditional medicine for centuries. It's the same anywhere they flourish. On the Arabian Peninsula, where *Aloe vera* originated, the water-retaining gel in its leaves was used mainly to treat burns, aid in wound healing, and address digestive issues. The common houseleek, sometimes dubbed the "*Aloe vera* of the north", has also played a significant role in traditional folk medicine. Figures of mythical proportions, like Hildegard von Bingen or Sebastian Kneipp, a forebear of all naturopaths, prized *Sempervivum* for its anti-inflammatory and analgesic properties, recommending an infusion of it for stomach ailments.

It's easy to understand why plants that weather hardships like drought, heat, and cold, always rejuvenating themselves, were credited with health-giving properties. Today, science has endorsed many of these applications. In *Aloe vera* alone, over 75 substances with medicinal traits have been identified—vitamins, minerals, enzymes, and pain-relieving compounds like salicylic acid.

NEXT PAGE | Before *Sempervivum tectorum* produces its strikingly star-shaped flowers, its leaf rosettes are a source of anti-inflammatory salves and infusions.

MEDIZIN & KOSMETIK

Aloe vera & Sempervivum

HEILEN MIT SUKKULENTEN?

AUS MUTTER NATURS APOTHEKE SIND SUKKULENTEN ALS MEDIZINPFLANZEN NICHT MEHR WEGZUDENKEN

Wo immer Sukkulenten wachsen, sind sie seit Jahrhunderten auch in der traditionellen Medizin als Heilmittel beliebt. Auf der Arabischen Halbinsel, wo *Aloe vera* heimisch ist, nutzte man das wasserspeichernde Gel in ihren Blättern vor allem bei Verbrennungen, zur Wundheilung oder bei Verdauungsbeschwerden. Als „*Aloe vera* des Nordens" wird bisweilen auch die Hauswurz bezeichnet. Sie spielte ebenfalls in der traditionellen Volksmedizin eine wichtige Rolle: Ob bei Hildegard von Bingen oder dem „Kräuterpfarrer" Sebastian Kneipp – *Sempervivum* wurde aufgrund seiner entzündungshemmenden und schmerzlindernden Eigenschaften geschätzt und bei Magenbeschwerden auch als Tee verordnet.

Es ist gut nachvollziehbar, dass man heilsame Kräfte vornehmlich den Pflanzen zusprach, die Widrigkeiten wie Dürre, Hitze und Kälte scheinbar unbeschadet überstanden und sich immer wieder selbst neues Leben einzuhauchen schienen. Heute bestätigen wissenschaftliche Untersuchungen viele dieser Anwendungen – allein bei *Aloe vera* wurden über 75 heilaktive Komponenten von Vitaminen und Mineralstoffen über Enzyme bis zu schmerzlindernden Stoffen wie Salizylsäure nachgewiesen.

NÄCHSTE SEITE | Ehe *Sempervivum tectorum* wunderschön sternförmige Blüten ausbildet, können aus den Blattrosetten entzündungshemmende Salben und Tees gewonnen werden.

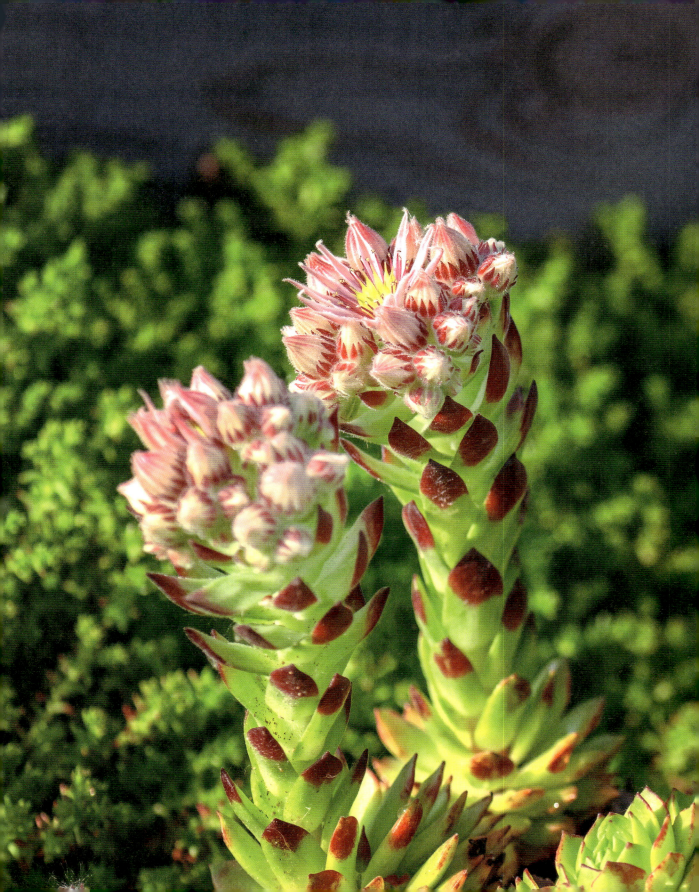

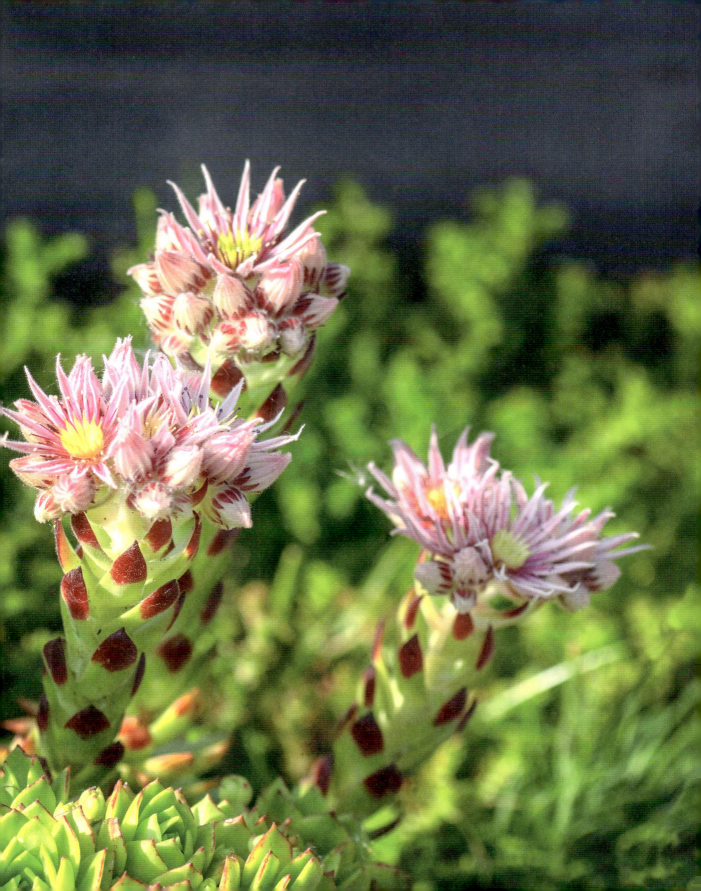

MEDICINE & COSMETICS

Aloe vera

THE REAL ALOE

A POWERFUL HEALER COVETED FOR COSMETICS

Of the roughly 500 species of aloe, only one boasts the title of "true", and as the name suggests, it's *Aloe vera*. While the bitter, yellow juice of its leaves has a laxative or—depending on the dosage—toxic effect, the hygroscopic gel within the leaf is highly sought-after. The gel contains a wide range of vitamins and minerals, and thanks to its moisturizing, anti-inflammatory, and wound-healing properties, it has long been employed in cosmetics, nutrition, and even for medicinal purposes.

DIE ECHTE ALOE

HEILKRÄFTIG UND BEGEHRT FÜR DIE SCHÖNHEIT

Unter den rund 500 Aloe-Arten hat nur eine den Anspruch, die einzig „wahre" zu sein: *Aloe vera*. Während der bittere gelbe Saft in ihren Blättern abführend und je nach Dosis toxisch wirkt, ist das wasserspeichernde Gel im Blattkern sehr begehrt: Es enthält ein breites Spektrum an Vitaminen und Mineralstoffen und wird aufgrund seiner Feuchtigkeit spendenden, entzündungshemmenden und wundheilenden Eigenschaften schon seit Langem in der Kosmetik, als Nahrungsmittel und sogar für medizinische Zwecke genutzt.

MEDIZIN & KOSMETIK

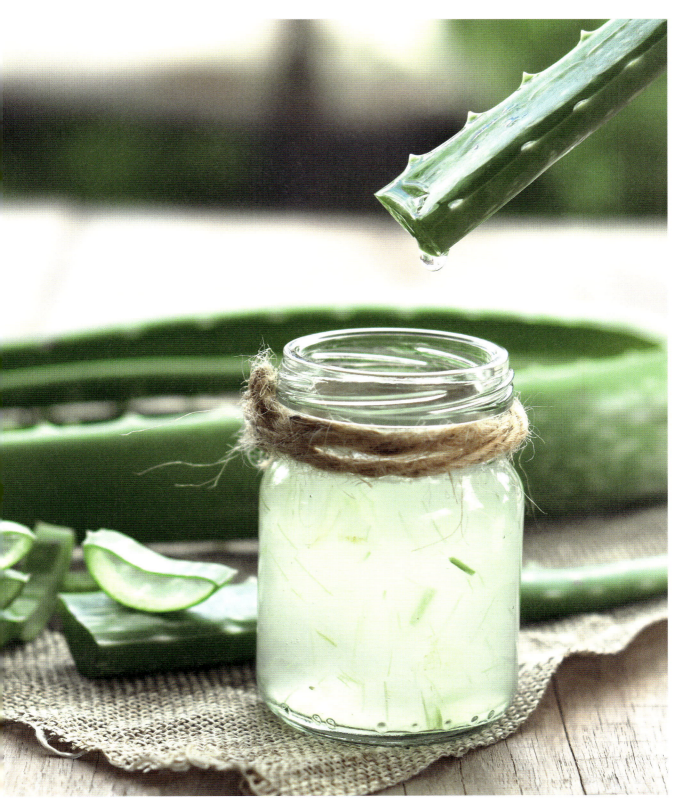

MEDICINE & COSMETICS

Lophophora williamsii

PEYOTE, THE PSYCHE-DELIC CACTUS

THIS CACTACEOUS HALLUCINOGEN HAS MADE A NAME FOR ITSELF FAR BEYOND MEXICO

The indigenous inhabitants of Mexico refer to a rather nondescript, spherical cactus species as peyote. The name derives from the Aztec word *peyōtl*, which can also translate to "divine messenger". Indeed, the species *Lophophora williamsii* was revered there, deity-like, many thousands of years ago.

The button-shaped tips of this spineless cactus contain over 50 different alkaloids. One of them is the psychoactive substance mescaline. From time immemorial, Mexico's indigenous people have harnessed its mind-altering effects for healing and religious rites. The mind-expanding trances that followed peyote consumption and the ritual song and dance that accompanied it were deemed impious superstitions by the Spanish missionaries of the sixteenth century. It seems they pushily insisted that peyote consumption be replaced by tequila, an intoxicating (yet non-hallucinogenic) spirit made from agave.

Mescaline underwent a resurgence in popularity in the 1950s and 1960s with the Beat generation typified by Allen Ginsberg. British author Aldous Huxley also experimented with the psychedelic substance and recounted his experiences in an essay, "The Doors of Perception".

MEDIZIN & KOSMETIK

Lophophora williamsii

PSYCHO-KAKTUS PEYOTE

DIE HALLUZINOGENE WIRKUNG MACHTE DEN KAKTUS WEIT ÜBER MEXIKO HINAUS BEKANNT

Als Peyote bezeichnen die indigenen Völker Mexikos eine eher unscheinbare kugelförmige Kakteenart, abgeleitet aus dem aztekischen *peyōtl*, was auch als „göttlicher Bote" übersetzt werden kann: Tatsächlich wurde *Lophophora williamsii* dort schon vor mehreren Jahrtausenden selbst beinahe wie eine Gottheit verehrt.

Die knopfförmigen Spitzen des dornenlosen Kaktus enthalten über 50 verschiedene Alkaloide, eines davon ist das psychoaktive Meskalin. Mexikos Ureinwohner nutzten seine berauschende Wirkung seit Urzeiten zu Heilzwecken, aber auch in ihren religiösen Ritualen. Die bewusstseinserweiternden Trancen mit rituellen Gesängen und Tänzen, die dem Konsum von Peyote folgten, waren für die spanischen Missionare des 16. Jahrhunderts gottloser Aberglaube. Anscheinend drangen sie darauf, den Peyote-Konsum durch den zwar auch berauschenden, aber nicht halluzinogenen Agavenschnaps Tequila zu ersetzen.

Mit der Beat Generation um Allen Ginsberg erfuhr die Kaktus-Droge Meskalin in den 1950er- und 1960er-Jahren ein Revival. Der britische Schriftsteller Aldous Huxley experimentierte ebenfalls mit der psychedelischen Droge und beschrieb seine Erfahrungen in dem Essay „Die Pforten der Wahrnehmung".

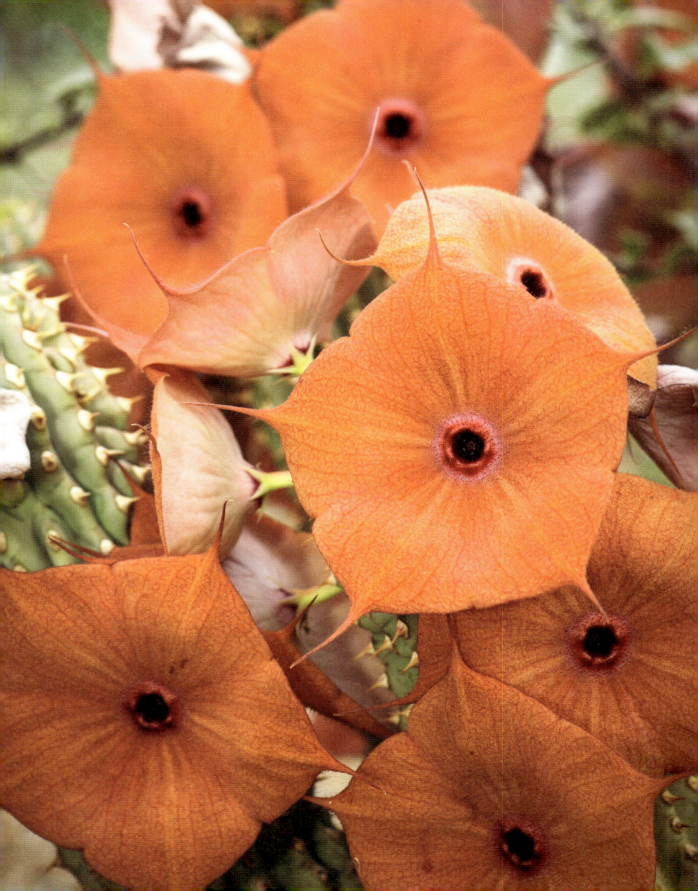

MEDIZIN & KOSMETIK

Hoodia gordonii

THE HOODIA DIET

MAKING HAY WITH A PURPORTED "MIRACLE PLANT"

Hoodia gordonii is a traditional medicinal plant utilized by the Khoisan, an indigenous people of the Kalahari Desert. They mainly use this thorny succulent, known locally as *kowa*, to suppress hunger during periods of scarcity or while hunting. When pharmaceutical and food companies caught wind of its appetite-suppressing properties, they began marketing a range of weight-loss pills containing *Hoodia* extract. None of these products is proven to work, and sadly the primary result of this scheme has been to significantly deplete the natural population of *Hoodia* in southwestern Africa.

MIT HOODIA AUF DIÄT

DAS GESCHÄFT UM EINE „WUNDERPFLANZE" MIT ZWEIFELHAFTER WIRKUNG

Für die Khoisan, die Ureinwohner der Kalahariwüste, ist *Hoodia gordonii* eine traditionelle Medizinpflanze: Sie nutzen die von ihnen *Kowa* genannte dornige Sukkulente vor allem, um in Notzeiten oder auf der Jagd ihr Hungergefühl zu unterdrücken. Als Pharma- und Lebensmittelkonzerne von diesem Effekt Wind bekamen, brachten diese eine Fülle an Abnehmpillen mit Hoodia-Extrakt, aber ohne wirklich nachgewiesenen Effekt, auf den Markt. Abgenommen hat dadurch leider hauptsächlich der natürliche Bestand an Hoodia-Pflanzen in Südwestafrika …

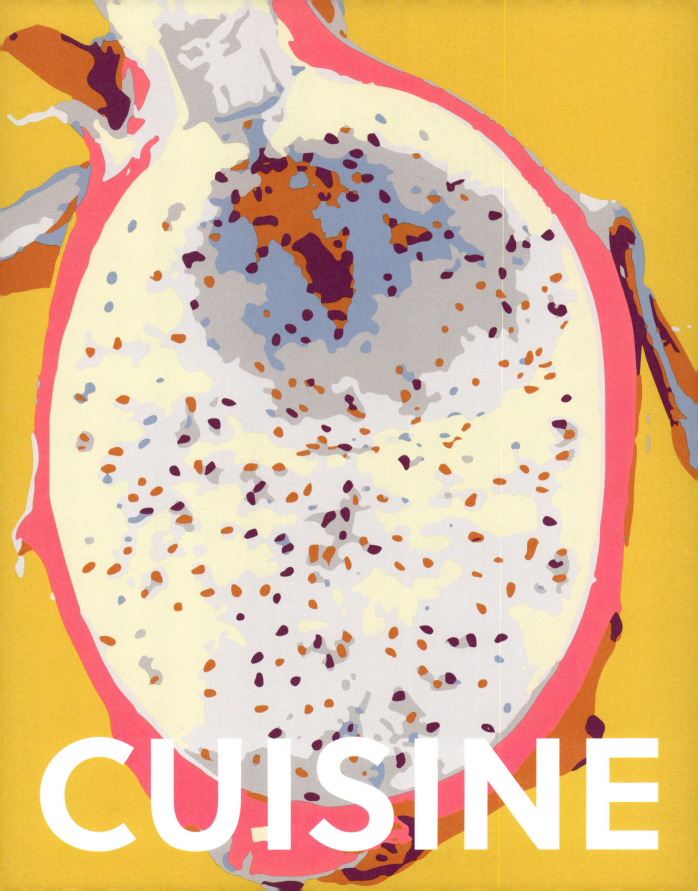

CUISINE

Portulaca oleracea and Claytonia perfoliata

WEEDS OR NATURE'S BOUNTY?

IF COMMON PURSLANE AND WINTER PURSLANE ARE WEEDS, THEN THE BEST SOLUTION IS TO GOBBLE THEM UP

Any amateur gardener who makes peace with the rampant sprawl of summer purslane will be rewarded with a tart, tasty, nut-flavored wild vegetable in *Portulaca oleracea*. It is a free supply of vitamins and nutrients. The same goes for its winter cousin, *Claytonia perfoliata*, which is sometimes mistaken for other species. Known as "miner's lettuce" because of its round, crunchy-succulent leaves, on your plate it is a garden-fresh green, even in winter, for it grows practically throughout the year in northern latitudes.

KULINARIK

Portulaca oleracea und Claytonia perfoliata

UNKRAUT ODER GESCHENKE DER NATUR?

DIE BESTE ART DER „UNKRAUTVERNICHTUNG" IN FALL VON SOMMERPORTULAK UND WINTERPORTULAK: EINFACH AUFESSEN!

Jeder Hobbygärtner, der mit dem üppig wuchernden Sommerportulak Frieden schließt, hat mit *Portulaca oleracea* ein köstliches säuerlich-nussiges Wildgemüse im Garten – und bekommt Vitamine und Nährstoffe frei Haus! Ähnliches gilt für den bisweilen verwechselten Winterportulak: *Claytonia perfoliata* wird aufgrund seiner runden, knackig-sukkulenten Blätter auch als Tellerkraut bezeichnet und bringt im Winter gartenfrisches Grün auf den Speiseplan, da er in nördlichen Breitengraden so gut wie ganzjährig wächst.

CUISINE

Adansonia digitata

BAOBAB

THIS GIANT SUCCULENT IS AFRICA'S "TREE OF LIFE"

The baobab tree is recognized as the largest succulent in the world. With mighty branches like gnarled roots stretching as much as 80 feet into the sky, *Adansonia digitata* can seem to have been thrust into the ground upside-down—by the devil himself, if folklore is any guide.

In Africa, the baobab is hailed as the "tree of life". Indeed, all its parts are harnessed. The leaves are prepared like spinach, while the tangy pulp of its fruit boasts higher vitamin C content than oranges and is an important source of protein and carbohydrates. It is consumed fresh or dried into a powder and used in both cooking and medicinally. Its large, hard-shelled seeds are a source of oil. The mighty trunk of the baobab tree is utilized in myriad ways. It can function as a natural cistern for people and animals, to which end it's often hollowed out so that a single tree can store hundreds or thousands of gallons of water. The enormous cavities within these trunks can also serve as granaries or pantries—or sometimes even as shelters or bus stops.

KULINARIK

Adansonia digitata

AFFENBROTBAUM

DIE RIESEN-SUKKULENTE WIRD AUCH AFRIKAS „BAUM DES LEBENS" GENANNT

Der Affenbrotbaum gilt als größte Sukkulente der Welt. Da sich seine mächtigen Zweige wie knorrige Wurzeln bis zu 25 Meter hoch in den Himmel strecken, wirkt *Adansonia digitata*, als wäre die Stammsukkulente kopfüber in den Boden gerammt worden – dem Volksglauben nach vom Teufel in Person.

In Afrika gilt der *Baobab* genannte Affenbrotbaum als „Baum des Lebens" – und tatsächlich werden alle Teile der Pflanze sinnvoll genutzt: Die Blätter werden wie Spinat als Gemüse zubereitet; das säuerliche Fruchtfleisch enthält mehr Vitamin C als Orangen und ist eine wichtige Quelle für Proteine und Kohlehydrate. Es wird frisch wie auch getrocknet als Pulver verwendet, sowohl in der Küche als auch als Heilmittel. Aus den großen, hartschaligen Samenkörnern gewinnt man Öl. Den mächtigen Stamm des Affenbrotbaums nutzt man auf faszinierend vielfältige Art: Als Regenwasserspeicher, der Mensch und Tier versorgt, wird er oft noch zusätzlich ausgehöhlt, sodass ein einziger Baum mehrere Tausend Liter Wasser fassen kann. Die Hohlräume in den riesigen Stämmen dienen auch als Vorratsspeicher – und bisweilen sogar als Unterstand oder Bushäuschen!

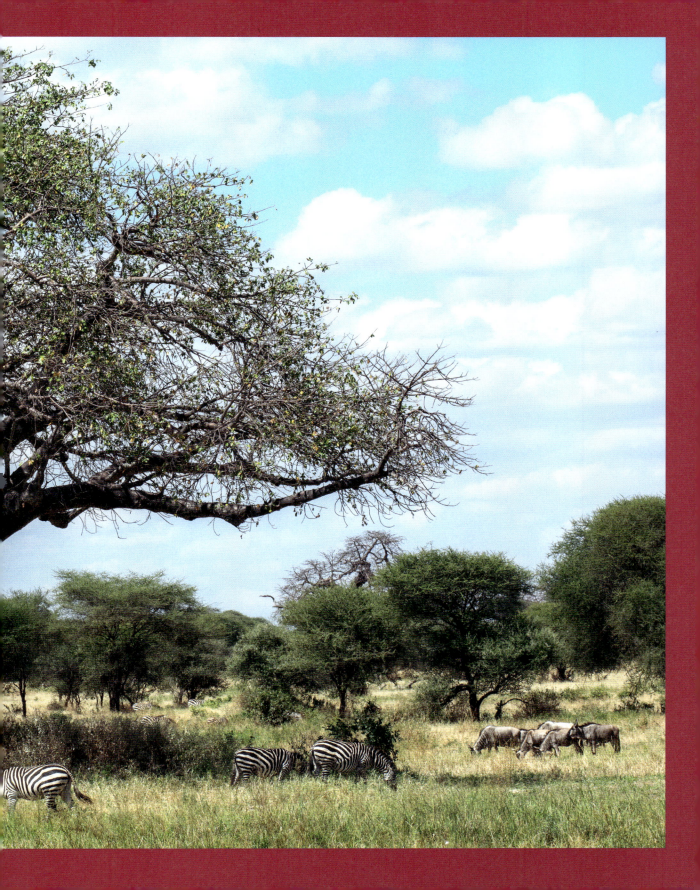

Opuntia

PRICKLY PEAR

WHATEVER THE NAME, *OPUNTIA* TASTES GOOD

In its native Mexico, *Opuntia*, the prickly pear cactus, is consumed by people, and I mean the entire plant. Its flat, oblong stem segments are served, often spiced, as nopales. *Opuntia's* fruit is a popular, refreshing snack food. Today, the prickly pear cactus has spread to many warm, dry regions around the world. However, prickly pear fresh off the plant should be handled with caution. The fruit is surrounded by fine thorns with truly horrific barbs.

KAKTUSFEIGE

FEIGENKAKTUS ODER KAKTUSFEIGE? OPUNTIA SCHMECKT IN JEDER REIHENFOLGE

Opuntia, der Feigenkaktus, wird in seiner Heimat Mexiko sozusagen mit „Haut und Haaren" verspeist: Als *Nopales* kommen die flachen, ovalen Stammsegmente der Kaktee auf den Tisch und werden gerne pikant zubereitet. Auch die Früchte der *Opuntia* sind ein beliebter, erfrischender Snack. Heute ist der Feigenkaktus in vielen warmen, trockenen Regionen rund um den Erdball zu finden. Eine Kaktusfeige frisch von der Pflanze ist aber mit Vorsicht zu genießen: Rund um die Frucht befinden sich viele feine Dornen mit fiesen Widerhaken!

CUISINE

Selenicereus undatus

DRAGON FRUIT

PRETTY IN PINK: THE DRAGON FRUIT, ALSO KNOWN AS PITAHAYA, IS AS PRETTY AS IT IS DELICIOUS

The cactus *Selenicereus undatus* originally hails from Mexico. But thanks to its delicious fruit, it's now also cultivated in tropical Southeast Asia. One glimpse at the vibrant-pink skin and radiant green tips of the fruit easily explains the pitahaya's common name, "dragon fruit". Its enormous blossoms are also impressive. For like queen of the night, they too only bloom for a single night, a fact that leads these two (related) species to be frequently confused.

KULINARIK

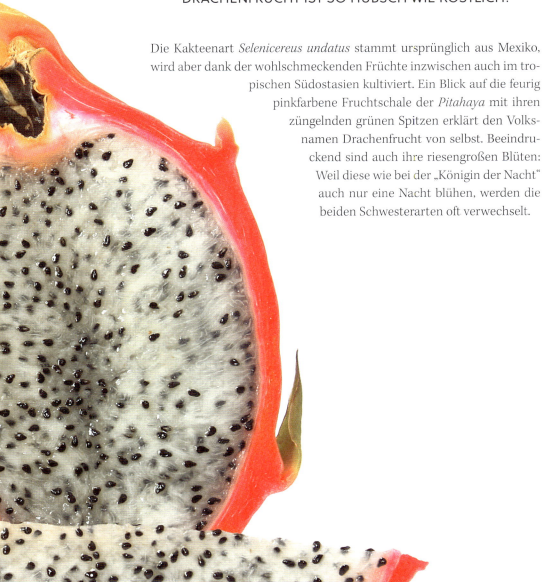

Selenicereus undatus

DRACHENFRUCHT

PRETTY IN PINK – DIE AUCH ALS PITAHAYA BEKANNTE
DRACHENFRUCHT IST SO HÜBSCH WIE KÖSTLICH!

Die Kakteenart *Selenicereus undatus* stammt ursprünglich aus Mexiko, wird aber dank der wohlschmeckenden Früchte inzwischen auch im tropischen Südostasien kultiviert. Ein Blick auf die feurig pinkfarbene Fruchtschale der *Pitahaya* mit ihren züngelnden grünen Spitzen erklärt den Volksnamen Drachenfrucht von selbst. Beeindruckend sind auch ihre riesengroßen Blüten: Weil diese wie bei der „Königin der Nacht" auch nur eine Nacht blühen, werden die beiden Schwesterarten oft verwechselt.

155

CUISINE

Salicornia & Crithmum maritimum

PICKLEWEED AND SEA FENNEL

SALT-LOVING SUCCULENT DELICACIES ON THE MARGINS OF THE INTERTIDAL ZONE

Succulents are survivors not only in arid conditions but also in other very challenging environments: *Salicornia*, or pickleweed, thrives in flood-prone salt marshes. As halophytes (salt-tolerant plants) they've evolved succulence as a survival strategy. Their tissues store water in vacuoles to regulate homeostasis, a severely challenging task given the salt-rich soil. This is why *Salicornia*, also known as glasswort or picklegrass, has a pleasant, briny flavor and is now considered a delicacy. The plant was once chiefly known as a source of soda ash, which was needed in large quantities to manufacture glass.

In English-speaking countries, the common name "samphire" can be a source of confusion as *Crithmum maritimum* carries the same moniker. But the latter, commonly known as "sea fennel", is in the carrot family, which a quick look at its fennel-like flowers can confirm. Its typical habitat is found in rocky coastal regions. Seafarers have prized the tangy sea fennel as food since antiquity as its proven vitamin C content helped fend off scurvy.

RIGHT PAGE | *Salicornia* grows in flood-prone salt marshes.
NEXT PAGE | Sea fennel contains a lot of vitamin C.

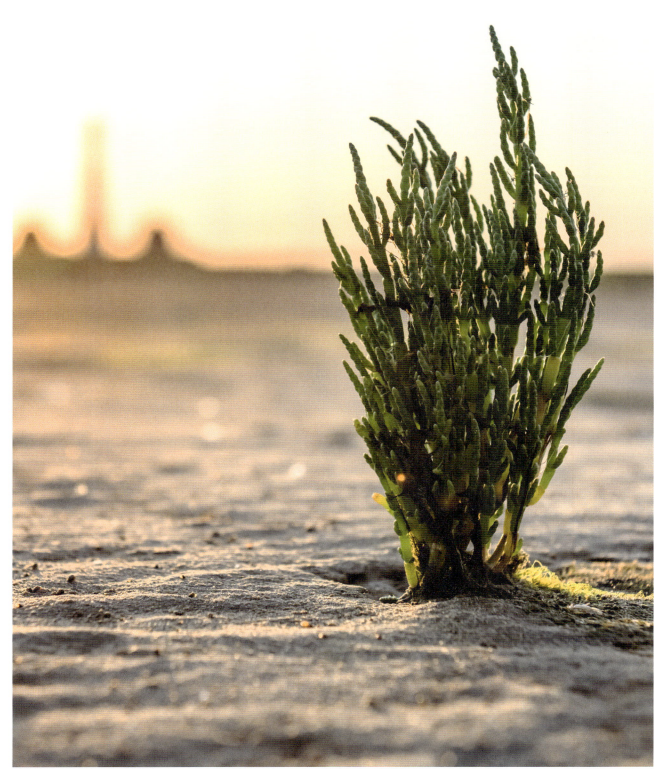

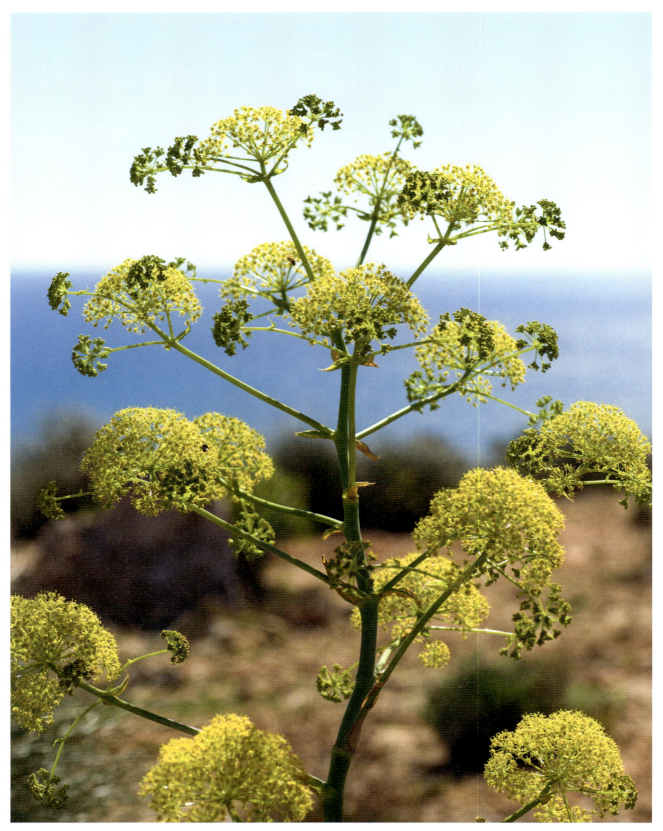

KULINARIK

Salicornia & Crithmum maritimum

QUELLER, MEERFENCHEL & CO.

DIE SALZ LIEBENDEN SUKKULENTEN LEBEN ZWISCHEN LAND UND MEER UND GELTEN ALS DELIKATESSE

Sukkulenten sind nicht nur Überlebenskünstler bei Trockenheit, manche von ihnen trotzen auch anderen Widrigkeiten: Die Fuchsschwanzgewächse *Salicornia* wachsen mitten im überfluteten Wattbereich. Als Halophyten, also Salzpflanzen, haben sie Sukkulenz als Überlebensstrategie entwickelt und regulieren über die wasserspeichernden Vakuolen ihren Salzhaushalt, der durch den Meeresboden extrem herausgefordert ist. Daher schmecken die als Queller oder Meeresspargel bekannten *Salicornia* angenehm würzig und gelten heutzutage als Delikatesse. Einst war die Pflanze vornehmlich als Glasschmelz bekannt: Aus ihrer Pflanzenasche konnte das zur Glasherstellung benötigte Soda in hoher Konzentration gewonnen werden.

Im englischsprachigen Raum sorgt der Popularname *Samphire* bisweilen für etwas Verwirrung, da auch *Crithmum maritimum* so bezeichnet wird. Die als Meerfenchel bekannte Sukkulente zählt aber zu den Doldenblütlern – ein Blick auf den an Fenchel erinnernden Blütenstand verrät es. Ihr typisches Habitat ist der felsige Küstenbereich. Schon seit der Antike schätzten Seefahrer den säuerlichen Meerfenchel als Verpflegung – und tatsächlich half ihr inzwischen nachgewiesener Vitamin-C-Gehalt, Skorbut vorzubeugen.

VORIGE SEITE | Queller *(Salicornia)* wächst auf Watt- und anderen salzigen Böden.
LINKE SEITE | Meerfenchel *(Crithmum maritimum)* enthält viel Vitamin C.

A BIZARRE VARIETY OF SHAPES

Kalanchoe pinnata and Kalanchoe daigremontiana

GOETHE AND THE AMAZING LEAF

A POET WAXES POETIC AT A PLANT THAT GROWS PLANTLETS

So fond was he of *Kalanchoe pinnata* (formerly *Bryophyllum calycinum*) that Johann Wolfgang von Goethe composed a poem dedicated to this plant. He even sent a sprouting leaf specimen to one of his muses, the actress and singer Marianne von Willemer. The miracle leaf has diverse medicinal properties for which it has been utilized in folk medicine for thousands of years, to treat fever, inflammation, kidney ailments, and more. But the botanically inclined Goethe was particularly fascinated by the succulent's reproductive strategy. Numerous plantlets emerge from the edges of its leaves. They often develop roots before they detach and settle, independent now, onto the ground. Goethe is said to have liked to share his enthusiasm for *Kalanchoe pinnata* by giving visitors such a leaf.

An even more prolific vegetative propagator is *Kalanchoe daigremontiana* (next page), which people often mistake for the Goethe plant. Its English popular name, "mother of thousands", is no coincidence. The tiny plantlets separate from the mother plant at the slightest touch, sometimes spreading uncontrollably—not always to the liking of amateur gardeners.

BIZARRE FORMENVIELFALT

Kalanchoe pinnata und Kalanchoe daigremontiana

GOETHES WUNDERBLATT

**WENN PFLANZEN NACHWUCHS „AUSBRÜTEN",
GERÄT SO MANCHER DICHTER INS SCHWELGEN ...**

Von *Kalanchoe pinnata*, ursprünglich als *Bryophyllum calycinum* klassifiziert, war Johann Wolfgang von Goethe so fasziniert, dass er der Pflanze ein Gedicht widmete und es mit einem Brutblatt-Exemplar an die Schauspielerin und Sängerin Marianne von Willemer, eine seiner Musen, schickte. Aufgrund seiner vielfältigen Inhaltsstoffe wurde das Wunderblatt seit Jahrtausenden in der Volksheilkunde bei Fieber, Entzündungen, Nierenleiden und vielem mehr eingesetzt. Der botanisch interessierte Dichter war aber vor allem von der Fortpflanzungsstrategie der Sukkulente fasziniert: An den Blatträndern der *Kalanchoe pinnata* wächst eine Vielzahl von Tochterpflanzen heran, die dort oft schon Wurzeln ausbilden und dann als fertige Pflanzen auf die Erde fallen. Es ist überliefert, dass Goethe Freunden, die zu Besuch weilten, gerne Kindeln des Brutblatts schenkte, um damit seine Begeisterung für die Pflanze weiterzugeben.

 Noch produktiver bei der vegetativen Vermehrung ist die oft mit der Goethepflanze verwechselte *Kalanchoe daigremontiana* (folgende Seite). Deren englischer Popularname *Mother of Thousands* kommt nicht von ungefähr: Die kleinen Babypflänzchen lösen sich schon bei der kleinsten Berührung von der Mutterpflanze ab, sodass sich das Brutblatt bisweilen unkontrolliert ausbreitet – nicht immer zur Freude von Hobbygärtnern.

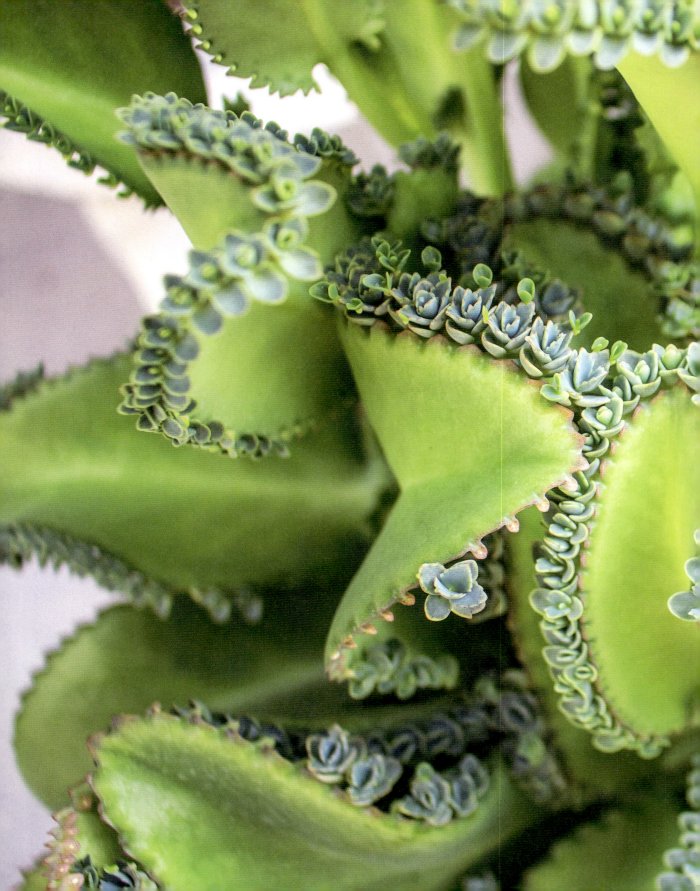

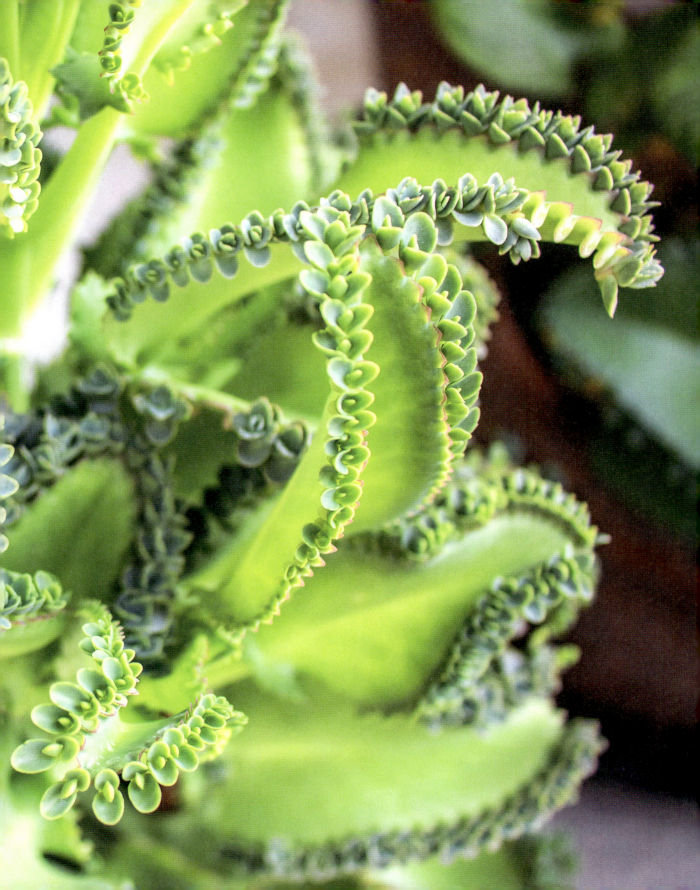

A BIZARRE VARIETY OF SHAPES

Haworthia cooperi

CRYSTAL CLEAR

LET THE SUNSHINE IN

Haworthia cooperi is a jewel among succulents in two ways. Its translucent leaf tips resemble crystal-clear gemstones. The beauty is also biologically functional: the darker the location, the more the succulent must do to absorb light for photosynthesis. *Haworthia cooperi* solves this problem by opening the windows, allowing sunlight into the interior of the leaf through a transparent epidermis.

GLASKLARES PFLANZENJUWEL

LASS DIE SONNE REIN …

Im doppelten Sinn ein Juwel unter den Sukkulenten ist *Haworthia cooperi*: Ihre durchscheinenden Blattspitzen erinnern an glasklare Edelsteine. Was wunderschön anzusehen ist, ergibt auch biologisch Sinn: Je dunkler der Standort ist, umso mehr muss sich die Sukkulente einfallen lassen, um Licht zur Photosynthese aufnehmen zu können. Die *Haworthia cooperi* löst das Problem, indem sie „die Fenster öffnet" – und so durch die transparente Außenhaut die Sonne ins Blattinnere leitet.

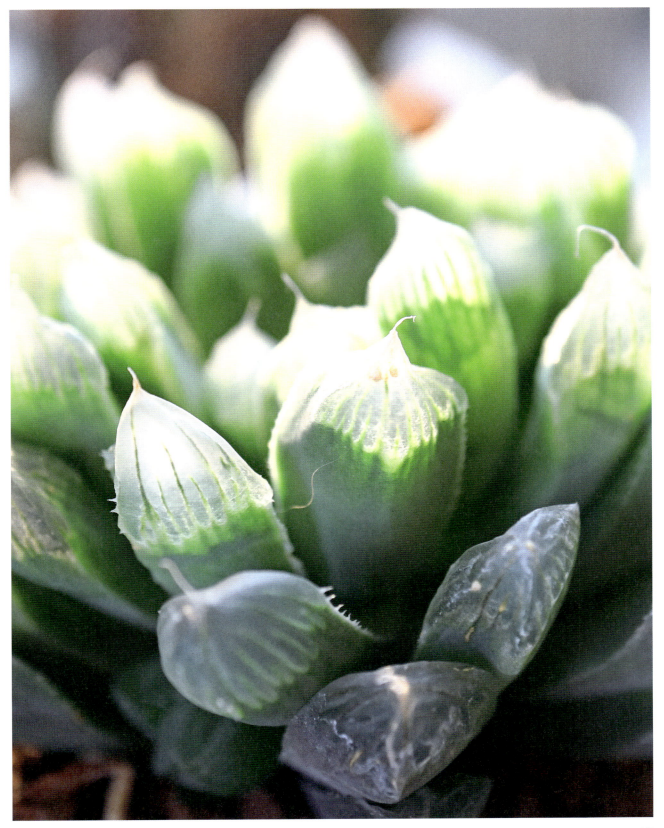

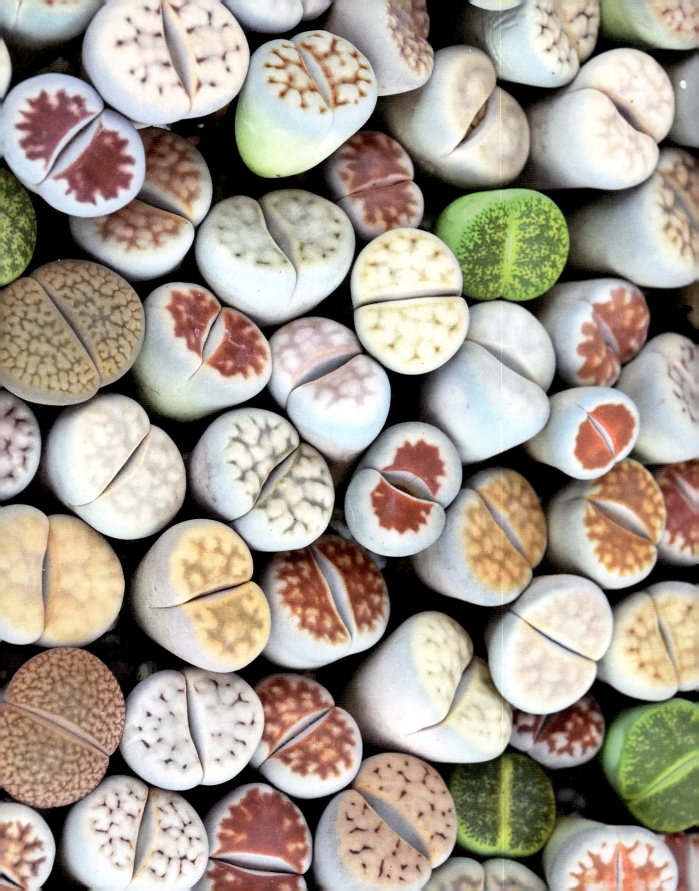

BIZARRE FORMENVIELFALT

Lithops

LIVING STONES

SUCCULENT PEBBLES

Lithops are fascinating leaf succulents in the Aizoaceae family. But you would not know it, and you might not even spot them, until they bloom, so well camouflaged are they as little nubby pebbles. During winter dormancy, the old leaf-pair dehydrates as a new one grows at the plant's center, where it is protected. In spring, a fresh pair of leaves emerges, with a gray-brown surface that perfectly matches the plant's natural environment.

LEBENDE STEINE

GANZ SCHÖN SAFTIG, DIESE KIESEL …

Dass auch *Lithops* zu den Mittagsblumengewächsen zählen, wird erst augenfällig, wenn die lebenden Steine erblühen. Doch auch ohne Blüte faszinieren die Blattsukkulenten – sofern man sie in ihrer Tarnung als knubbelige Kieselsteine entdeckt. In der Winterruhe dehydriert das alte *Lithops*-Blattpaar, während in seiner Mitte geschützt ein neues heranwächst. Wenn dieses im Frühling dann zutage tritt, tarnt ihre graubraune Blattoberfläche die lebenden Steine in ihrer natürlichen Umgebung perfekt.

A BIZARRE VARIETY OF SHAPES

Cotyledon tomentosa

BEAR'S PAW

DOWNY PAWS, SMALL CLAWS

When *Cotyledon tomentosa* stretches skyward with its thick, fine-haired leaves with serrated edges, it's hard not to compare them to the fluffy paws of a teddy bear. No wonder this succulent, which hails from South Africa, can generate so much enthusiasm from its perch in front of a living room window. The star-shaped flowers in delicate orange and honey yellow only add to the effect. For many a bear likes to soak its paws in honey …

BÄRENTATZE

FLAUSCHIGE PFÖTCHEN MIT KLEINEN KRALLEN

Wenn *Cotyledon tomentosa* die fein behaarten dicken Blätter mit gezackten Rändern in die Höhe streckt, muss man sofort an die flauschigen Tatzen eines Teddybären denken – kein Wunder, dass die aus Südafrika stammende Sukkulente auch am Pflanzenfenster im Wohnzimmer für Begeisterung sorgt. Und auch die sternförmigen Blüten in zartem Orange und Honiggelb passen ins Bild – schließlich taucht so mancher Bär seine Tatzen gerne in Honig …

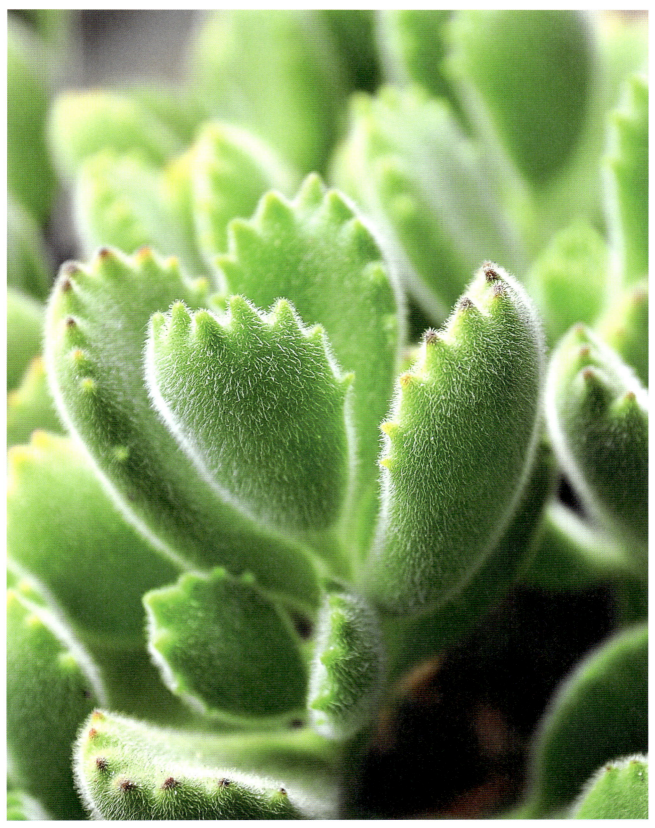

A BIZARRE VARIETY OF SHAPES

Senecio rowleyanus

STRING-OF-PEARLS

SOME THINK PEAS. OTHERS THINK BEADS ON A STRING

The miniature, spherical leaves growing on long strands of *Senecio rowleyanus* make this leaf succulent one of the most striking succulents to have found its way into the living room. This heat-loving "pea" plant has taken the principle of maximizing water storage over surface area to the extreme. Its spheroid leaves, tightly hung on strands that can grow to more than three feet long, make them perfect ornamentals that drape down. Hanging these plants also puts its tempting and, unfortunately, poisonous "peas" beyond the reach of pets or small children.

In the Cape region of South Africa, where it is a native species, this succulent grows as ground cover in the shade of other plants. So as a houseplant, it does not care much for direct sunlight either. The fact that the narrow stomata on the globe-shaped leaves resemble squinting eyes may also serve as a modest reminder that this plant prefers shadier venues.

Senecio rowleyanus

ERBSENPFLANZE

FÜR DIE EINEN SIND ES ERBSEN, FÜR DIE ANDEREN PERLEN AN EINER SCHNUR

Die kugeligen Miniblätter an den langen Strängen der *Senecio rowleyanus* machen sie zu einer der auffälligsten Sukkulentenarten, die ihren Weg in diverse Wohnzimmer gefunden haben. Das Prinzip „maximales Wasserspeichervolumen bei minimaler Oberfläche" hat die Wärme liebende Erbsenpflanze mit ihren Blattkugeln auf die Spitze getrieben: Diese reihen sich dicht an dicht – an Strängen, die bis zu einem Meter lang werden können. Perfekt, um dekorativ als Hängepflanzen inszeniert zu werden. Ein Vorteil dabei: Die verlockend aussehenden, aber leider giftigen „Erbsen" sind somit außerhalb der Reichweite von kleinen Kindern und Haustieren!

In der südafrikanischen Kapregion wächst die Sukkulente als Bodendecker im Schatten anderer Pflanzen, daher schätzt sie auch als Zimmerpflanze kein direktes Sonnenlicht: Dass die schmalen Spaltöffnungen zur Lichtaufnahme an den Kugelblättern an blinzelnde Augen erinnern, mag als kleine Erinnerung an einen schattigen Standort dienen.

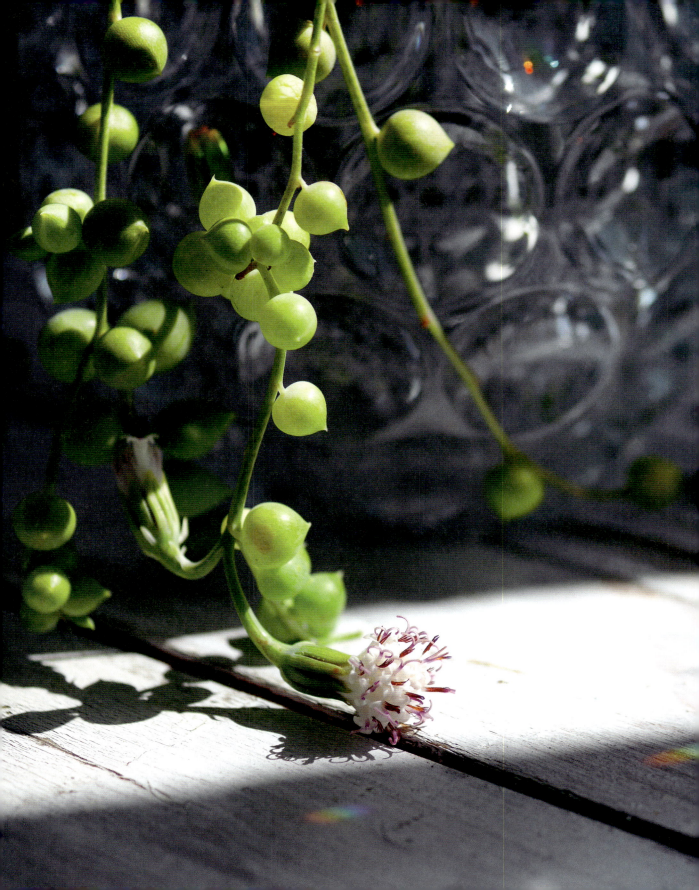

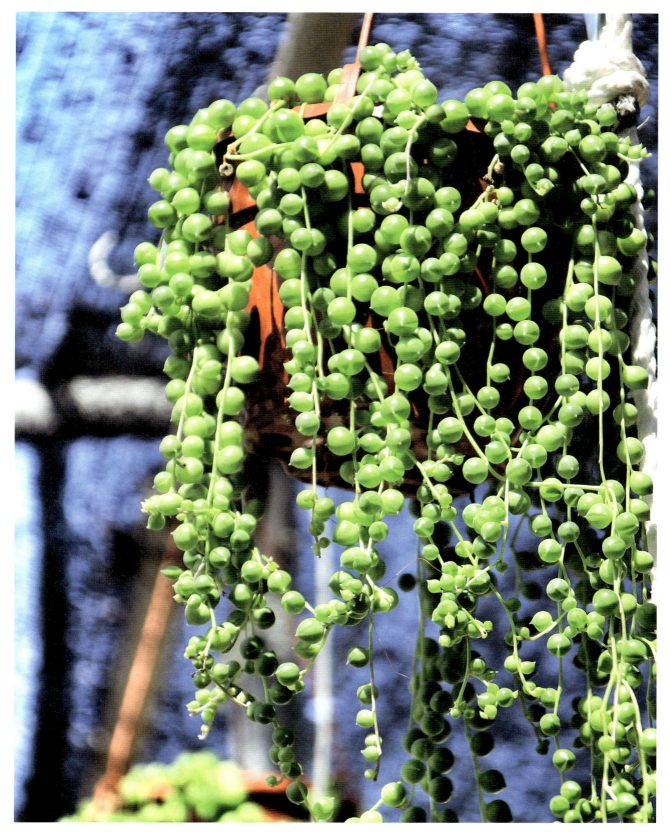

A BIZARRE VARIETY OF SHAPES

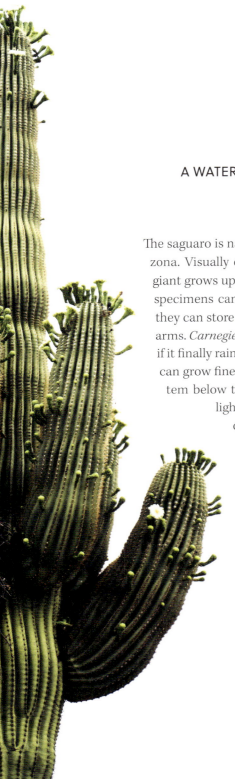

Carnegiea gigantea

SAGUARO

A WATER-STORAGE WIZARD WITH MANY TRICKS UP ITS SLEEVE

The saguaro is native to the Sonoran Desert between Mexico and Arizona. Visually considered the archetype of all cactuses, this desert giant grows up to 50 feet tall and is a master of survival. Fully grown specimens can survive up to seven years without precipitation, as they can store around 1,300 gallons of water in their stems and side arms. *Carnegiea gigantea* is also characterized by quick turn-around: if it finally rains after years of drought, within a few hours the cactus can grow fine root hairs on its widely distributed, shallow root system below the soil surface, soaking up precious precipitation at lightning speed before it evaporates. In this way, saguaros can reach the almost biblical age of 150 to 200 years, even under the most inhospitable conditions. Many of these official state plants of Arizona are older than the state of Arizona.

BIZARRE FORMENVIELFALT

Carnegiea gigantea

SAGUARO

DER WASSERSPEICHERKÜNSTLER HAT VIELE TRICKS AUF LAGER

In der Sonora-Wüste zwischen Mexiko und Arizona ist der Saguaro heimisch. Der optisch als Urbild aller Kakteen geltende Gigant der Wüste wird bis zu 15 Meter hoch – und ist der Überlebenskünstler par excellence: Bis zu sieben Jahre können ausgewachsene Exemplare ohne Niederschläge überleben, da sie im Inneren von Stamm und „Armen" rund 5000 Liter Wasser speichern können. Auch Schnelligkeit zeichnet *Carnegiea gigantea* aus: Regnet es nach jahrelanger Dürre dann doch einmal, kann der Kaktus an seinem breit gefächerten, flach unter der Bodenoberfläche verlaufenden Wurzelsystem innerhalb weniger Stunden feine Wurzelhaare wachsen lassen – und so blitzschnell den kostbaren Niederschlag aufsaugen, ehe dieser verdunstet ist. Auf diese Weise können Saguaro-Kakteen auch unter den unwirtlichsten Bedingungen das fast biblische Alter von 150 bis 200 Jahren erreichen: So sind zahlreiche der offiziellen „Staatspflanzen" von Arizona älter als der Bundesstaat an sich!

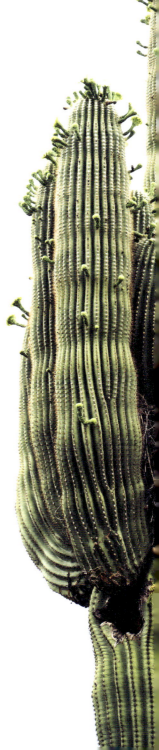

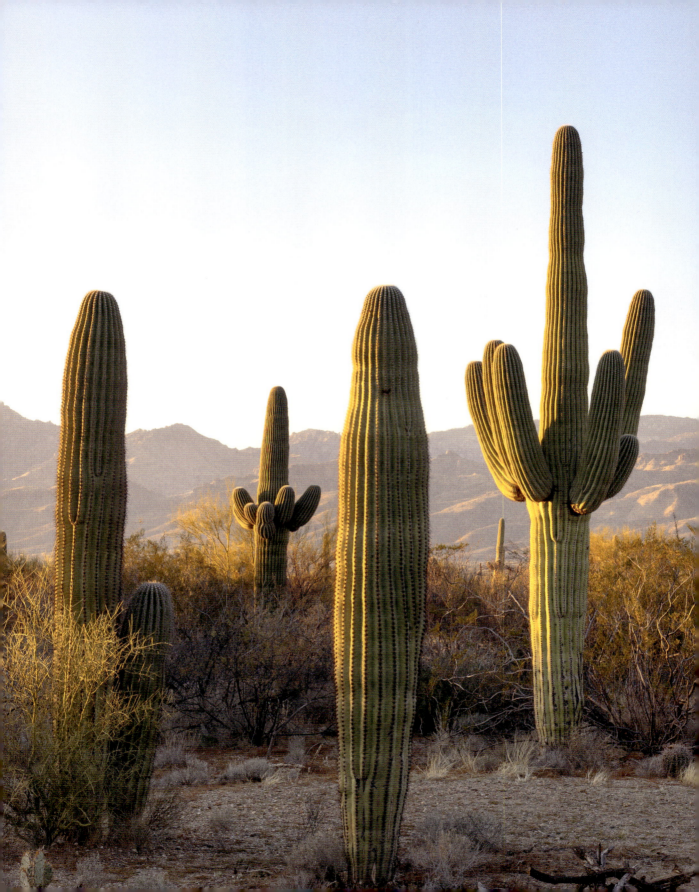

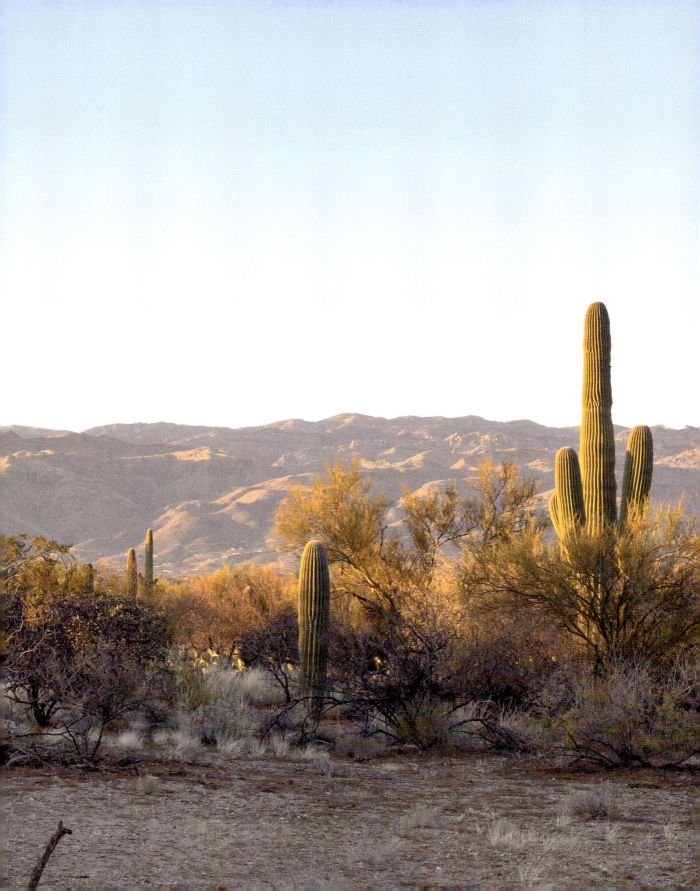

A BIZARRE VARIETY OF SHAPES

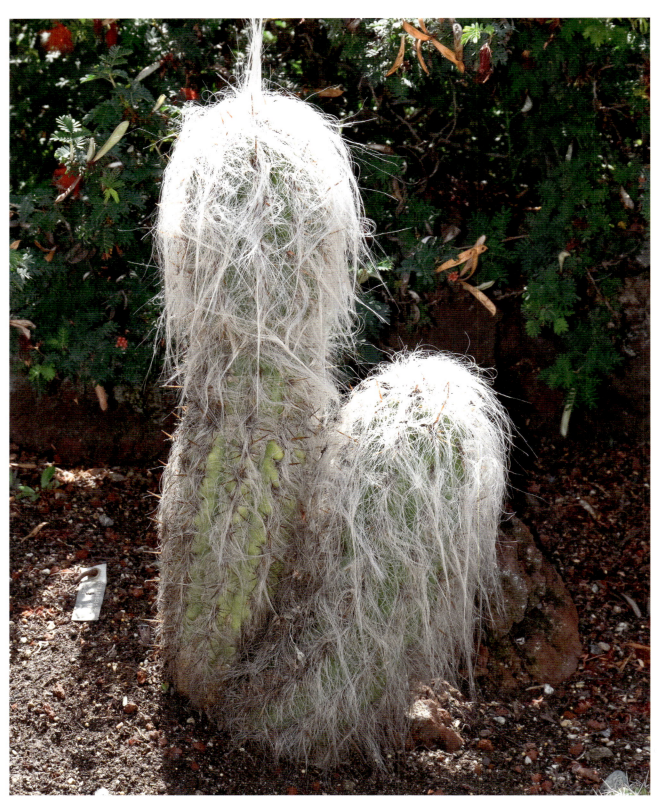

BIZARRE FORMENVIELFALT

Cephalocereus senilis

OLD MAN CACTUS

A HEAT SHIELD OF WISPY HAIR

Majestic woolly-white giants tower as high as 50 feet above the Mexican desert. Stimulated by sunlight, long silvery-white hairs grow from the old man's areoles, eventually enveloping the entire stem and shielding it from too much sun. This practical insulation gives the cacti a look that's part cotton candy, part Gandalf the Grey. An old man cactus reaches a respectable age when it has lived for around 200 years. For all that longevity, it can also take up to 20 years before these cactuses bloom.

GREISENHAUPT

WUSCHELIGE HAARPRACHT ALS HITZESCHUTZ

Majestätisch erheben sich die wollig-weißen Giganten bis zu 15 Meter hoch über die mexikanische Wüste. Angeregt durch Sonnenschein, wachsen aus ihren Areolen lange silberweise Haare, die bald den ganzen Stamm umhüllen und dann vor zu starker Sonneneinstrahlung schützen: eine Art „Dämmwolle", die die Kakteen wie einen Mix aus Zuckerwatte und Gandalf dem Grauen aussehen lässt. Mit rund 200 Jahren erreicht ein Greisenhaupt ein ansehnliches Alter – dafür lässt es sich auch gerne mal bis zu 20 Jahre Zeit, um zur Blüte zu kommen.

A BIZARRE VARIETY OF SHAPES

Selenicereus grandiflorus

QUEEN OF THE NIGHT

AND SHE BLOOMED ONLY FOR ONE NIGHT ...

Scarcity raises demand. And thus has *Selenicereus grandiflorus* attained an almost mythical reputation. The queen of the night blooms only once a year, and in truly spectacular fashion. While delightful, her majesty's grand appearance is short-lived. The magnificent flower—it can measure a foot across—unfurls two hours before midnight. By the break of dawn, the spectacle is already over. Besides this fleeting enchantment, queen of the night is your typical, easygoing cactus, not some pretended diva.

DIE KÖNIGIN DER NACHT

ALLERDINGS WIRKLICH NUR EINER NACHT!

Wer sich rar macht, wird umso mehr bewundert – so hat sich *Selenicereus grandiflorus* einen geradezu mythischen Ruf erworben: Die Königin der Nacht blüht nur ein einziges Mal im Jahr, dafür aber sehr spektakulär! Bei ihrem majestätischen Auftritt währt das Glück nur kurz: Zwei Stunden vor Mitternacht öffnet sich die prachtvolle, bis zu 30 Zentimeter große Blüte, und ehe der Morgen anbricht, ist das Spektakel schon wieder vorbei. Ansonsten gibt sich die Königin der Nacht übrigens kaktustypisch pflegeleicht, ganz ohne divenhaft-royale Attitüden.

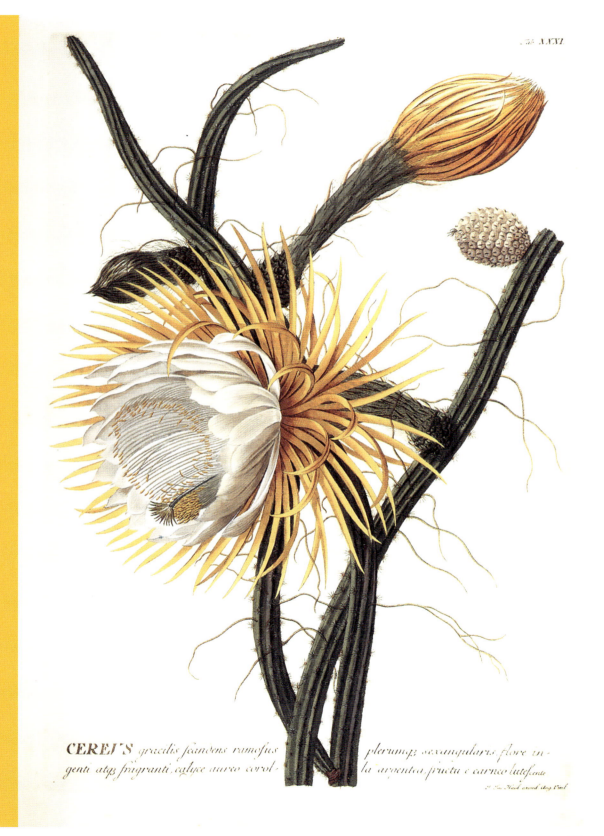

CEREUS gracilis scandens ramosus plerumq; sexangularis, flore ingenti atq; fragranti, calyce aureo corol la argentea, fructu e carneo lutescente

FUN FACTS

Schlumbergera species & Hatiora gaertneri

CHRISTMAS AND EASTER CACTUSES

HOW DO HOLIDAY CACTUSES KNOW WHEN TO BLOOM?

The Christmas and Easter cactuses often get lumped together, but even though both these tropical cactuses originate in the Brazilian rainforest, they are members of different genera. These "holiday cactuses" are distinguished by the shapes of their flowers and leaves: *Hatiora gaertneri* puts out flat, star-shaped blossoms around Easter, while the winter-blooming *Schlumbergera* species have an elongated inflorescence. A handy way to remember this is to look at the leaf shape of the segmented stems: the Easter cactus *Hatiora gaertneri* is characterized by rounded, ovate leaves, whereas the leaves of the *Schlumbergera* are (more or less) distinctly serrated—in a way that can resemble the silhouette of a Christmas tree.

In Europe, all *Schlumbergera* species are generally considered Christmas cactuses. In the United States, they are further differentiated: *Schlumbergera truncata*, which blooms in November, is known as the Thanksgiving cactus. *Schlumbergera x buckleyi* gets the commercial designation "Christmas cactus" all to itself. All the holiday cactuses are short-day plants, meaning that they only flower when the nighttime darkness period is sufficiently long, with cool temperatures. Gardeners in northern latitudes can cleverly control exactly when this happens to make sure the cactuses bloom for the right holiday.

FUN FACTS

Schlumbergera-Arten & Hatiora gaertneri

WEIHNACHTSKAKTUS, OSTERKAKTUS & CO.

WOHER WISSEN DIE FEIERTAGSKAKTEEN, WANN SIE BLÜHEN SOLLEN?

Weihnachtskaktus und Osterkaktus werden gern in einen Topf geworfen, doch auch wenn beide Tropenkakteen aus dem brasilianischen Regenwald stammen, gehören sie verschiedenen Gattungen an. Unterscheiden kann man beide „Feiertagskakteen" sowohl an Blüten- als auch Blattformen: *Hatiora gaertneri* blühen um Ostern flach und sternförmig, währen die winterblühenden *Schlumbergera*-Arten einen länglichen Blütenstand haben. Eine Eselsbrücke bietet ein Blick auf die Blattform der gegliederten Triebe: Der Osterkaktus *Hatiora gaertneri* zeichnet sich durch abgerundete, eiförmige Blätter aus, die Blätter der *Schlumbergera* hingegen sind mehr oder weniger ausgeprägt gezackt – man denke hier an die Silhouette eines Weihnachtsbaums. Während in Mitteleuropa die *Schlumbergera*-Arten insgesamt als Weihnachtskakteen gelten, wird in den USA noch weiter differenziert: *Schlumbergera truncata* blüht im November als Thanksgiving-Kaktus, *Schlumbergera x buckleyi* wird als Weihnachtskaktus gehandelt. Alle Feiertagskakteen sind Kurztagpflanzen; das bedeutet, dass sie erst zur Blüte angeregt werden, wenn sie eine ausreichend lange Phase von nächtlicher Dunkelheit und Kühle erfahren haben. Wann genau dies in unseren nördlichen Breiten eintritt, kann von Gärtnern geschickt gesteuert werden – passend zu den jeweiligen Feiertagen.

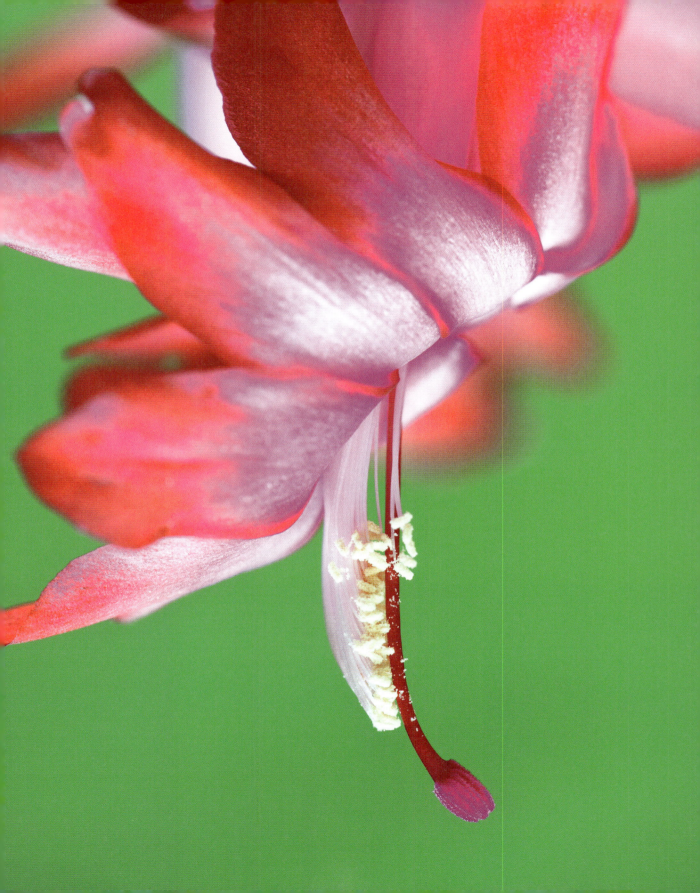

The actual "Christmas cactus", *Schlumbergera x buckleyi* (right), flowers later than the "Thanksgiving cactus", *Schlumbergera truncata* (left). Europeans don't distinguish these festive cactuses— when is Thanksgiving, anyway?

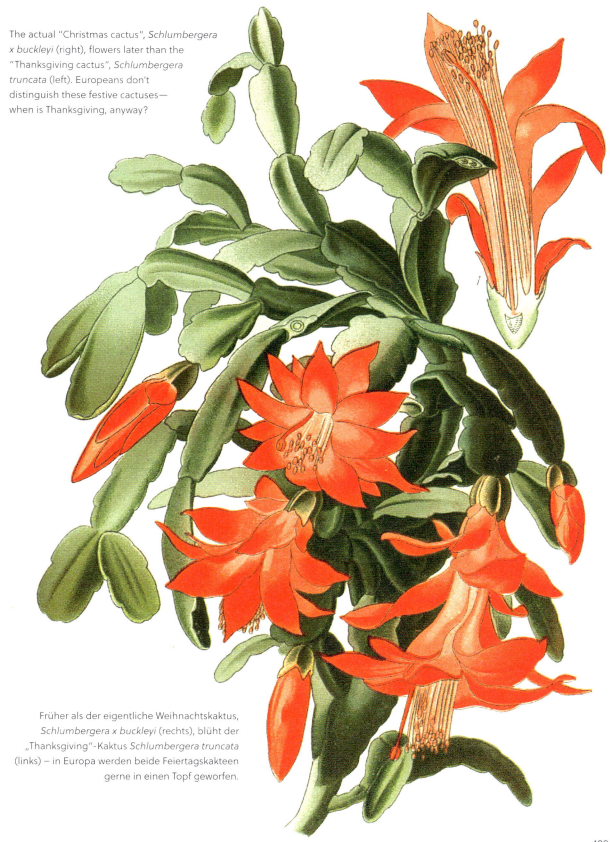

Früher als der eigentliche Weihnachtskaktus, *Schlumbergera x buckleyi* (rechts), blüht der „Thanksgiving"-Kaktus *Schlumbergera truncata* (links) – in Europa werden beide Feiertagskakteen gerne in einen Topf geworfen.

FUN FACTS

Euphorbia leuconeura

MILK BUSH

BEWARE OF THIS AGGRESSIVE SPREADER

Euphorbia leuconeura, often referred to also as the Madagascar jewel, is basically a llama among stem succulents. As llamas are known to spit, this stem succulent may disperse its seeds several feet away, and many a plant enthusiast has been surprised to find small apparent offshoots of the milk bush sprouting unexpectedly in distant flowerpots.

SPUCKPALME

ACHTUNG, ANGRIFF: DIESE PFLANZE VERBREITET SICH GANZ SCHÖN AGGRESSIV

Die *Euphorbia leuconeura* ist quasi das Lama unter den Stammsukkulenten, und zwar aufgrund einer ganz bestimmtem „Unart": Die Spuckpalme neigt dazu, ihre Samen gleich mehrere Meter weit zu schleudern – und so mancher Pflanzenfreund war schon irritiert, in weit entfernten Blumentöpfen plötzlich kleine Ableger der Spuckpalme vorzufinden!

FUN FACTS

Sedum species

WHITE STONECROP, THE SECRET WEAPON OF LAZY GARDENERS

A CLEANER-UPPER AND A PLEASER OF INSECTS

Tired of weeding around the bricks and stones? If you've planted sedum in your garden, you can kiss this hassle goodbye. The equation is simple: where a ground-covering stonecrop species thrives, there's no more room for weeds. *Sedum album* is a robust leaf succulent and the perfect partner for your walkways. Known as "white stonecrop", it eagerly spreads and adapts to its surroundings. Any small offshoot that gets separated will just grow into a new plant, and its white flowers are a haven for bees. Similarly, *Sedum acre*, or gold moss stonecrop, with its bright yellow flowers, is a magnet for pollinators. It works miracles in terms of breathing life into bare walls and barren gravel. This versatile plant is so resilient, it can find a home in the tiniest wall crevice. And if you plant *Sedum rupestre* along the path to your herb garden, you'll be doubly rewarded. Also known as trip-madam, this refreshingly sour succulent is a traditional medicinal and culinary herb. Rich in vitamin C, it can provide a nutritious boost to your meals all year round.

FUN FACTS

Sedum-Arten

MAUERPFEFFER ALS GEHEIMWAFFE FÜR FAULE GÄRTNER

EIN „SAUBERMANN", DER AUCH INSEKTEN GLÜCKLICH MACHT

Unkraut entfernen zwischen Wegplatten? Wer *Sedum* im Garten hat, ist diese Sorge los. Die Formel ist einfach: Wo eine der bodendeckenden Mauerpfeffer-Arten wächst, hat kein Unkraut mehr Platz. Die robuste Blattsukkulente *Sedum album* ist der ideale Weg-Begleiter: Buchstäblich auf Schritt und Tritt verbreitet sich der Weiße Mauerpfeffer. Jedes kleine Stück, das abgetrennt wird, wächst zu einer neuen Pflanze heran – und wird mit seinen weißen Blüten zur Bienenweide.

Dank seiner kleinen gelben Blüten ist der Scharfe Mauerpfeffer ebenfalls ein Bienenmagnet – und eine Wunderwaffe für alle, die kahlen Mauern und tristen Geröllflächen Leben einhauchen möchten: *Sedum acre* ist so anspruchslos, dass es schon in der kleinsten Mauerritze einen Lebensraum findet.

Und wer am Wegesrand zum Küchengarten *Sedum rupestre* pflanzt, hat doppelt Freude: Die erfrischend säuerliche Sukkulente, auch Tripmadam genannt, ist ein altbekanntes Heil- und Küchenkraut und reich an Vitamin C, sodass sie das ganze Jahr über den Speiseplan gesund aufwerten kann.

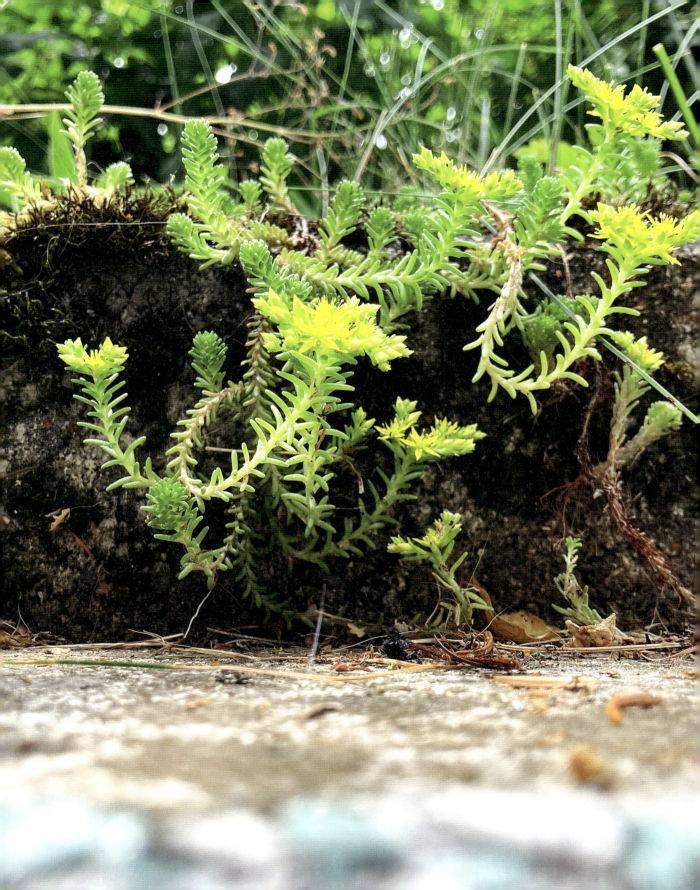

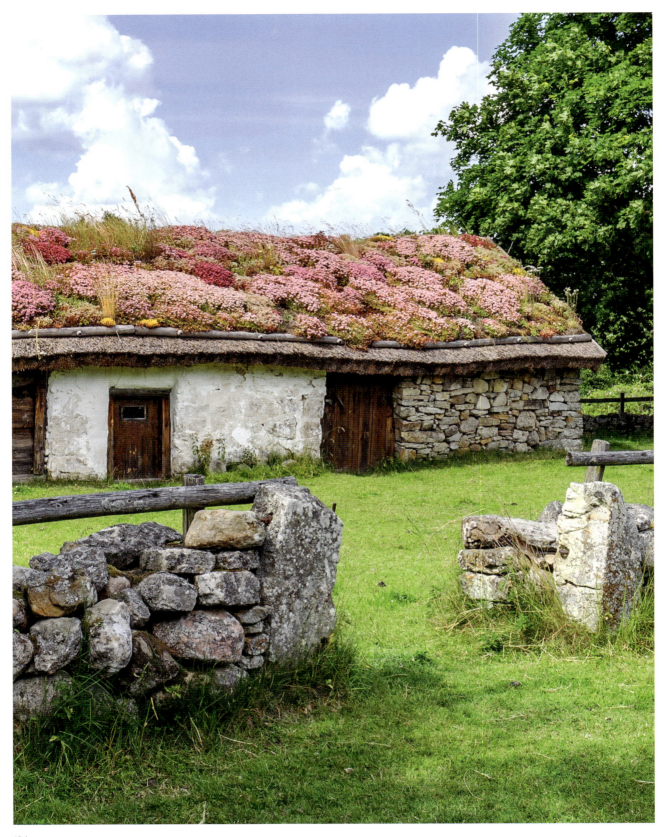

Sempervivum tectorum

PROTECTED BY THE COMMON HOUSELEEK

GREEN ROOFS JUST THE LATEST FAD? THINK AGAIN. *SEMPERVIVUM TECTORUM* IS TRIED AND TRUE

Sempervivum tectorum, the common houseleek, has been utilized atop roofs for millennia. Even Charlemagne is known to have directed the planting of *Sempervivum* on rooftops in his administrator's handbook, the "Capitulare de villis". This was due both to its perceived medicinal value as well as to the belief that its root system would secure loose clay and tile roofing. Folk wisdom even credited houseleeks with protection against lightning strikes. To this day in Wales, common houseleek is seen as a lucky charm for those residing under roofs formed of it.

SCHUTZ FÜRS DACH

IST DACHBEGRÜNUNG NUR „NEUMODISCHER UNSINN"? DIE DACHWURZ BEWEIST SEIT LANGEM DAS GEGENTEIL!

Sempervivum tectorum, die Dachwurz, wird schon seit Jahrtausenden zur Bepflanzung von Häusern genutzt: Auch Karl der Große ordnete in seiner Land- und Wirtschaftsverordnung *Capitulare de villis* an, auf Dächern *Sempervivum* anzubauen. Sie galt als Heilpflanze, sollte aber durch ihr Wurzelgeflecht auch lose Lehm- und Ziegeldächer befestigen. Der Volksglaube schrieb Dachwurzen zudem eine Schutzwirkung gegen Blitzschlag zu – und in Wales gelten sie nach wie vor als Glücksbringer für alle, die unter diesem Dach leben.

FUN FACTS

Agave americana & Agave tequilana

MESCAL & TEQUILA

SWEET AND INTOXICATING, AGAVE IS AN EXTREMELY VERSATILE CROP SPECIES

O, sweet death! *Agave americana* is harvested just before it blooms, not for its flowers but for the sweet sap stored in its heart, also known as the *piña*. *Aguamiel*, "honey water", is extracted and processed into agave syrup, a popular sweetener especially in vegan diets as a honey substitute. When agave hearts are steamed or roasted and the resulting syrup fermented, it forms the base for mescal, probably Mexico's most iconic distilled spirit. Mind you that the Aztecs revered the agave as a sacred medicinal plant—whence mescal's unofficial designation as the "elixir of the gods". Legend has it that a divine lightning bolt once cleaved an agave plant in two, distilling its juice into mescal. In fact, Spanish colonists introduced the distillation of agave syrup in the sixteenth century.

But isn't Mexico's national drink tequila? Correct! Tequila is a kind of mescal produced exclusively from blue agave, *Agave tequilana*. And why is there the infamous "worm" in agave spirits? An agave plantation once faced an infestation with these caterpillars. One savvy producer of mescal noted the unique flavor these pests imparted, decided to market it as a sign of quality, and even began placing a "worm" in each bottle as a gimmick.

NEXT PAGE | Agave harvest in Mexico (left), caterpillar in a tequila bottle (right)

FUN FACTS

Agave americana & Agave tequilana

MESKAL & TEQUILA

SÜSS UND BERAUSCHEND: ALS NUTZPFLANZE IST DIE AGAVE ÄUSSERST VIELSEITIG

Komm, süßer Tod! Kurz bevor die *Agave americana* zum Blühen kommt, wird sie geerntet: In ihrem Herzen, *piña* genannt, befindet sich süßes *aguamiel*, „Honigwasser". Der daraus gewonnene Agavendicksaft ist vor allem in der veganen Ernährung als Alternative zu Honig beliebt. Dämpft oder röstet man die Agavenherzen und fermentiert den daraus gewonnenen Sirup, hat man die Basis für das vielleicht beliebteste Destillat Mexikos gewonnen: Meskal. Den Azteken war die Medizinpflanze Agave übrigens heilig, und so verwundert es nicht, dass Meskal auch als „Elixier der Götter" bezeichnet wurde: Einer Legende zufolge spaltete die Macht eines göttlichen Blitzes eine Agave und brannte deren Saft zu Meskal. Tatsächlich wurde die Destillation von Agavensirup erst durch die spanischen Kolonisten im 16. Jahrhundert eingeführt.

Moment mal, ist das Nationalgetränk Mexikos etwa nicht Tequila? Ganz richtig: Tequila ist eine Art von Meskal, der aber nur aus der Blauen Agave, *Agave tequilana*, gewonnen wird. Und warum ist im Agavenschnaps „der Wurm drin"? Eigentlich ist es eine Raupe, die eine Agavenplantage befallen hatte. Ein gewiefter Meskalproduzent erklärte den durch die Raupen veränderten Geschmack des Getränks zum Qualitätsmerkmal – und packte als PR-Gag absichtlich noch einen „Wurm" in jede Flasche!

NÄCHSTE SEITE | Agavenernte in Mexiko (links), Raupe in einer Tequilaflasche (rechts)

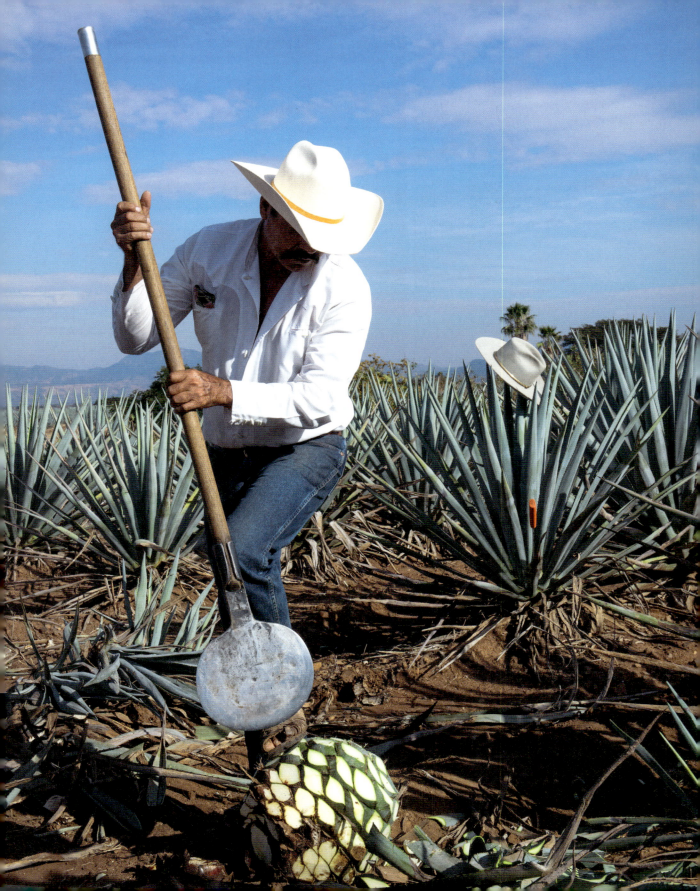

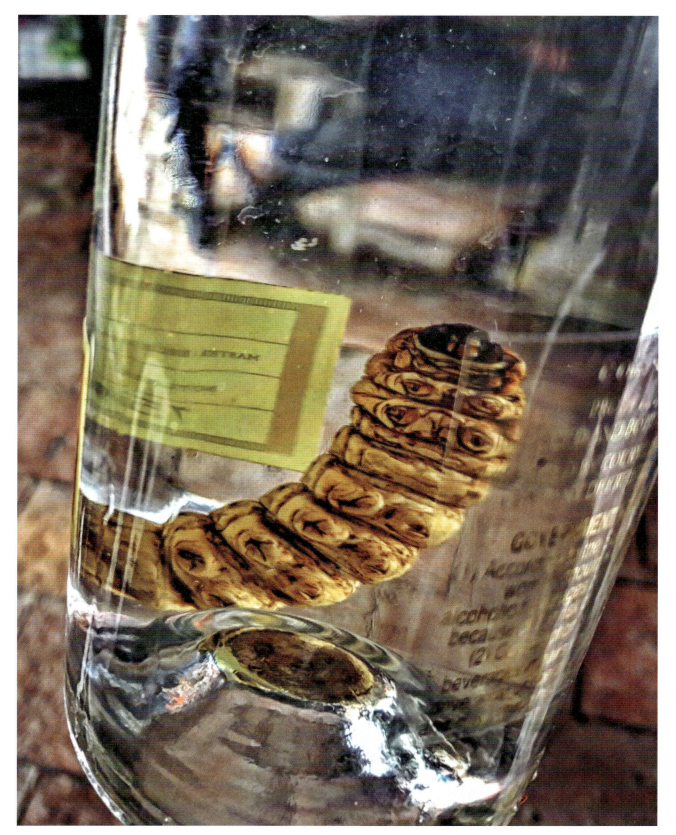

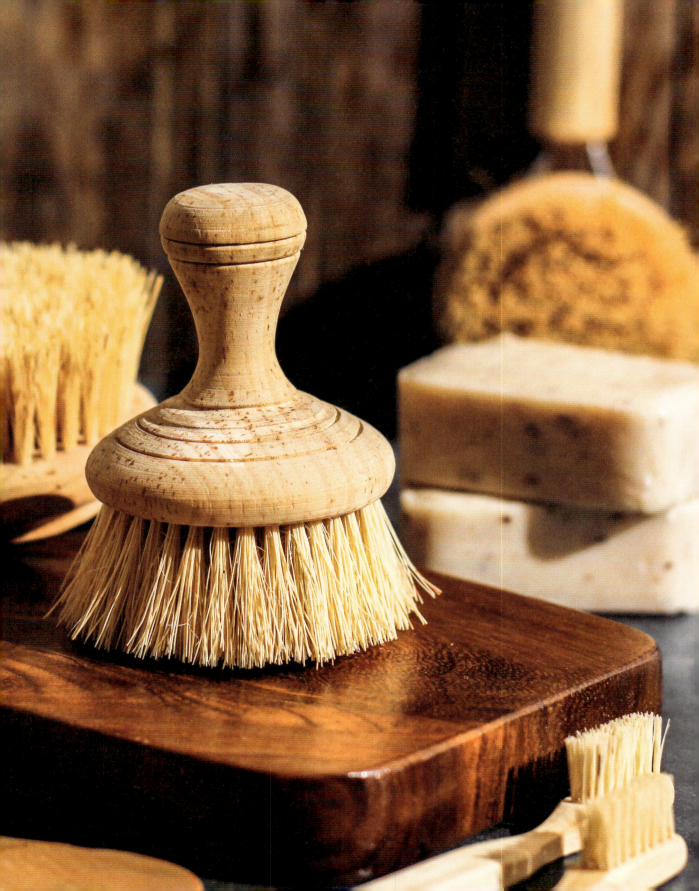

FUN FACTS

Agave lechuguilla

ULTRA-TOUGH AGAVE FIBERS

Agave leaves harbor many secrets. In the case of *Agave lechuguilla*, its leaves contain plant fibers up to 30 inches long. The fiber is known in Mexico as *ixtle*, and it forms the "backbone" of the agave's long leaves. *Ixtle* fiber boasts remarkable properties. They are acid-resistant and can withstand heat up to nearly 400 degrees Fahrenheit. Moreover they don't build up static electricity. For thousands of years, people laboriously extracted *ixtle* from agave by hand, using the robust fibers to make durable brushes.

DIE POWER-FASER AUS DER AGAVE

So manches Geheimnis verbirgt sich im Inneren von Agavenblättern – bei *Agave lechuguilla* sind es bis zu 75 Zentimeter lange Pflanzenfasern, in Mexiko als *Ixtle* bekannt, die das „Rückgrat" der langen Agavenblätter bilden. Die Power-Faser hat außergewöhnliche Qualitäten: Sie ist säurebeständig, hält bis zu 200 Grad Celsius an Hitze stand und lädt sich nicht statisch auf. Seit Jahrtausenden wird *Ixtle* in aufwendiger Handarbeit aus der Agave extrahiert, um daraus zum Beispiel äußerst robuste Bürsten herzustellen.

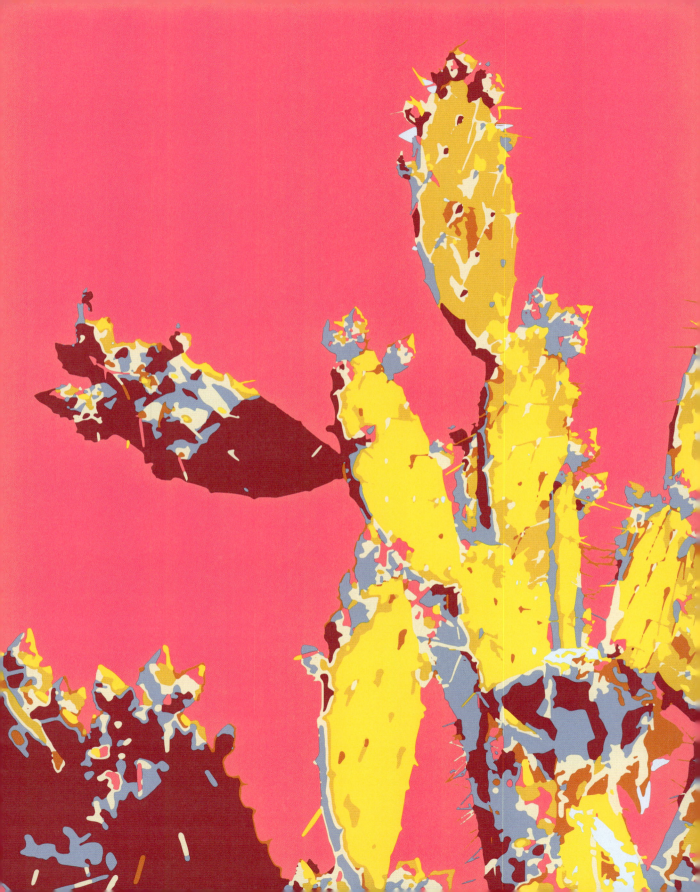

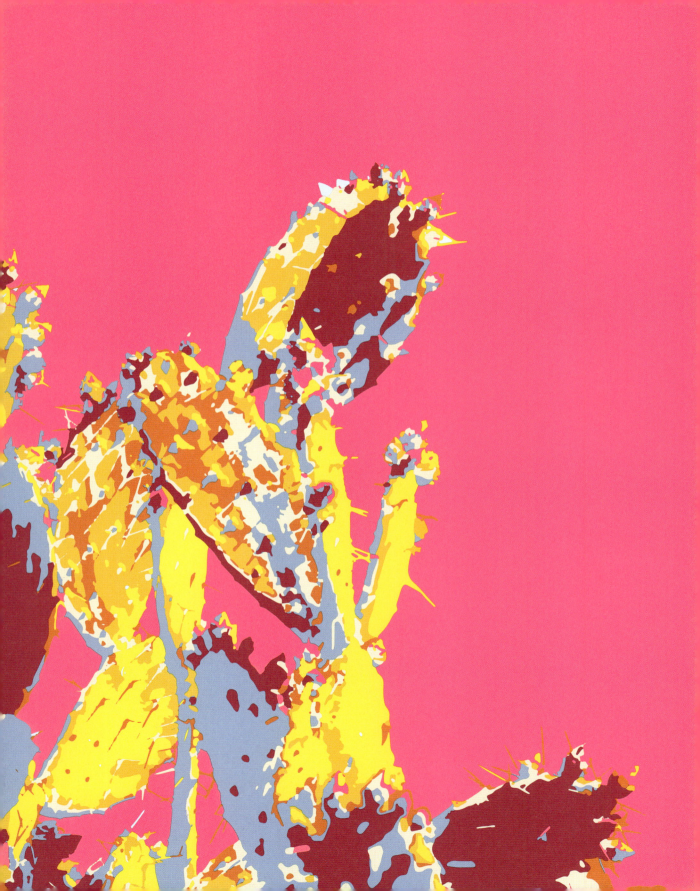

PICTURE CREDITS | BILDNACHWEIS

p. 2 illustration: Eva Stadler, p. 9 Sweeming YOUNG/stock.adobe.com, p. 10, 11 asharkyu/shutterstock.com, p. 12 Milada Vigerova/unsplash, p. 12 Ralf Liebhold/Alamy Stock Photos/mauritius images, p. 14 Lindsey/unsplash, p. 16 illustration: Eva Stadler, p. 18 FollowThe Flow/stock.adobe.com, p. 22 George Pagan/unsplash, ,p. 25 JSirlin/stock.adobe.com, p. 26 Jenifoto/stock.adobe.com, p. 29 Annie Spratt/unsplash, p. 32 miss_mafalda/stock.adobe.com, p. 34 Teressa L. Jackson/stock.adobe.com, p. 37 M. Schuppich/Alamy Stock Photos/mauritius images, p. 38 Panattar/stock.adobe.com, p. 40 illustration: Eva Stadler, p. 42 Alan/stock.adobe.com, p. 44 David Pastyka/stock.adobe.com, p. 47 Toms/stock.adobe.com, p. 48 Westend61/Lisa und Wilfried Bahnmüller/mauritius images, p. 50 Anja Kaiser/stock.adobe.com, p. 51 Lucie Douezi/unsplash, p. 52 Heritage Images/Imago Images, p. 53 Anja Kaiser/stock.adobe.com, p. 54, 55 Roman Ivanschenko/stock.adobe.com, p. 56 Memento/Florilegius/mauritius images, p. 59 Marina/stock.adobe.com, p. 60, 61 Somchai Thongseeda/Alamy Stock Photos/mauritius images, p. 63 Roland T. Frank/mauritius images, p. 64 Schauerman/stock.adobe.com, p. 67 Karin Jähne/stock.adobe.com, p. 68 illustration: Eva Stadler, p. 71 nature picture library/Cyril Ruoso/mauritius images, p. 72 Taborisova/stock.adobe.com, p. 75 Angie Yeoh/shutterstock.com, p. 76 Claud Richmond/unsplash, p. 78 crimson/stock.adobe.com, p. 80 SoniaBonet/stock.adobe.com, p. 82 irairopa/stock.adobe.com, p.85 Pietro Tasca/shutterstock.com, p. 86 Garden Guru/stock.adobe.com, p. 88 illustration: Eva Stadler, p. 90 ChrWeiss /stock.adobe.com, p. 93 ruckszio/stock.adobe.com, p. 94 Chawalit Siwaborwornwattana/shutterstock.com, p. 97 vainillaychile/stock.adobe.com, p. 98 illustration: Eva Stadler, p. 100 Feey/unsplash, p. 103 Kostiantyn Vierkieiev/unsplash, p. 106 Oporty786/stock.adobe.com, p. 107 kittisak/stock.adobe.com, p. 108 illustration: Eva Stadler, p. 110 Chao Sum/unsplash, p. 114 Leonoaro Iheme/unsplash, p. 116,117 phive2015/stock.adobe.com, p. 119 Britta Preusse/unsplash, p. 120 Annie Spratt/unsplash, p. 123 Art and Soil Bangalore/unsplash, p. 124 Amy Chen/unsplash, p. 127 Adolfo Felix/unsplash, p. 128 All Canada Photos/Alamy Stock Photos/mauritius images, p. 131 KE Magoon/Alamy Stock Photos/mauritius images, p. 132 illustration: Eva Stadler, p. 136 Freia/stock.adobe.com, p. 139 lovelyday12/stock.adobe.com, p. 140 lolloj/stock.adobe.com, p. 142 Roger de la Harpe/stock.adobe.com, p. 144 illustration: Eva Stadler, p. 147 Christian Jung/stock.adobe.com, p. 151 Science Source/Dan Suzio/mauritius images, p. 153 ccestep8/stock.adobe.com, p. 154 Joachim/stock.adobe.com, p. 157 Westend61/Kerstin Bittner/mauritius images, p. 158 Olaf Speier/stock.adobe.com, p. 160 illustration: Eva Stadler, p. 164 xzotica65/stock.adobe.com, p. 167 jobi_pro/stock.adobe.com, p. 168 chakkritt/stock.adobe.com, p. 171 YuanChieh/stock.adobe.com, p. 174 may5/stock.adobe.com, p. 175 SoniaBonet/stock.adobe.com, p. 176,177 Diego Lozano/unsplash, p. 178 James/stock.adobe.com, p. 180 Ed Lau/Alamy Stock Photos/mauritius images, p. 183 Johann Jacob Haid via Wikipedia, p. 184 Iillustration: Eva Stadler, p. 188 Flowerphotos/Gillian Plummer/mauritius images, p. 189 Sunny Celeste/Alamy Stock Photos/mauritius images, p. 191 FotoHelin/stock.adobe.com, p. 192 Bernd Zoller/imageBroker/mauritius images, p. 195 Eva Stadler, p. 196 Lars Johansson/stock.adobe.com, p. 200 jgpatino/stock.adobe.com, p. 201 Antwon McMullen/shutterstock.com, p. 202 ricardo/stock.adobe.com, p. 204 illustration: Eva Stadler, p. 207 Anja Klaffenbach

ABOUT THE AUTHOR | DIE AUTORIN

Anja Klaffenbach wurde die Liebe zur Natur mehr oder weniger in die Wiege gelegt: Im Garten ihrer Mutter, einer passionierten Blumenfreundin und Freizeitgärtnerin, entdeckte sie schon von klein auf die große Vielfalt der heimischen Pflanzenwelt. Nachdem ihr Studium der Anglistik und Romanistik sie nach England führte, war ihre Faszination für Gartenkunst besiegelt. Mittlerweile hat sie sich in ihrem Zuhause in einer bayerischen Großstadt den Traum vom eigenen Garten verwirklicht. Wenn sie nicht gerade als freie Texterin und Autorin Bücher über Reisen und Pflanzenvielfalt schreibt, erprobt sie dort ihren grünen Daumen mit dem Erkunden neuer und altbekannter Gemüse- und Zierpflanzen.

Anja Klaffenbach has been a nature-lover more or less since birth. Her mother, a passionate flower enthusiast and amateur gardener, kept a garden where Anja from an early age grew familiar with the immense diversity of local flora. She became enthralled with the art of gardening while studying English and Romance languages and literature in England. Today she has realized her dream of cultivating a garden of her own at her home in a large Bavarian city. When she isn't busy freelance-copywriting or authoring books about travel and botany, you'll find her in the garden, where she works out her green thumb at the exploration of novel and heirloom varieties of edibles and ornamentals alike.

© 2023 teNeues Verlag GmbH

Text: Anja Klaffenbach
English Translation: John Augustus Foulks
Picture Editing: Heide Christiansen
Design: Eva Stadler
Copy Editing: Dunja Reulein
Proofreading: Simona Fois
Editorial Coordination: Johannes Abdullahi, teNeues Verlag
Production: Sandra Jansen, teNeues Verlag
Photo Editing, Color Separation: Jens Grundei, teNeues Verlag

ISBN German Cover: 978-3-96171-493-3
ISBN English Cover: 978-3-96171-546-6
Library of Congress Number: 2023941900
Printed in the Czech Republic by PBtisk a.s.

Picture and text rights reserved for all countries. No part of this publication may be reproduced in any manner whatsoever.

While we strive for utmost precision in every detail, we cannot be held responsible for any inaccuracies, neither for any subsequent loss or damage arising.

Every effort has been made by the publisher to contact holders of copyright to obtain permission to reproduce copyrighted material. However, if any permissions have been inadvertently overlooked, teNeues Publishing Group will be pleased to make the necessary and reasonable arrangements at the first opportunity.

Bibliographic information published by the Deutsche Nationalbibliothek:
The Deutsche Nationalbibliothek lists this publication in the Deutsche Nationalbibliografie; detailed bibliographic data are available on the Internet at dnb.dnb.de.

Published by teNeues Publishing Group

teNeues Verlag GmbH
Ohmstraße 8a
86199 Augsburg, Germany

Düsseldorf Office
Waldenburger Straße 13
41564 Kaarst, Germany
e-mail: books@teneues.com

Augsburg/München Office
Ohmstraße 8a
86199 Augsburg, Germany
e-mail: books@teneues.com

Press Department
e-mail: presse@teneues.com

teNeues Publishing Company
350 Seventh Avenue, Suite 301
New York, NY 10001, USA
Phone: +1-212-627-9090
Fax: +1-212-627-9511

www.teneues.com